LANDSCAPE PAINTING

Permalba®, Turpenoid®, Jenkins Happy Medium™, Jenkins Sta-Brite Varnish™, Floral Pink™ and Misty Colors™ are Trademarked products of Martin/F. Weber Company, Wayne and Windrim Avenues, Philadelphia, Pennsylvania 19144.

ISBN 0-917121-01-5

LANDSCAPE PAINTING

by Gary Jenkins
written with
Vera A. Donovan
and Phillip C. Myer

Credits

Publisher
 Dennis Kapp

Executive Director
 Edward J. Flax

Art Director
 Phillip C. Myer

Editor
 Vera A. Donovan

Editorial Assistant
 Dorothy Schwartz

Production Artist
 Jean Brubaker

Photographer
 Bill Dobos

Typesetter
 Lynn Dinnell

Paintings and Line Drawings
 Gary Jenkins

Printed in U.S.A.
First Printing, 1984

CONTENTS

Dedication and Acknowledgement 7
Meet the Author .. 8
Introduction ... 10
Supplies ... 11
Paints .. 12
Mediums ... 14
Brushes .. 15
Materials .. 16
Basics .. 17
Landscapes .. 22
Garden's Gate ... 24
Country Barn .. 32
Flowing Tree .. 38
Desert Encounter ... 46
Summer Byway ... 52
Wonders in the Grass .. 60
Winter's Walk ... 66
Hidden Stream .. 74
Additional Artwork .. 80

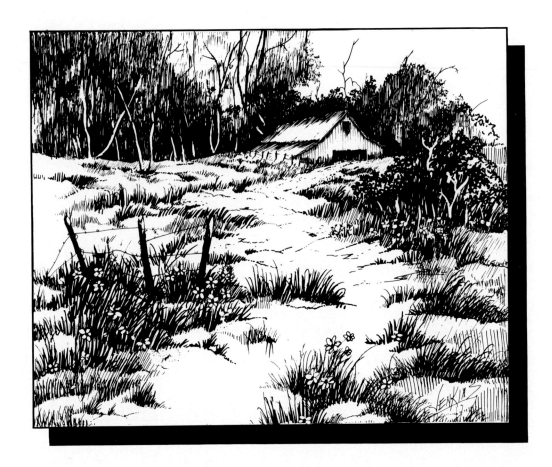

Gary Jenkins is the author of several other publications which can be purchased at your local art and craft supply store.

Floral Painting
Magic of Floral Painting
Magic of Floral Painting II

All Gary Jenkins products, brushes, and publications can be found in your local store or you can write to the following address for information on where they can be obtained.

Martin/F. Weber Company
Wayne & Windrim Avenues
Philadelphia, PA 19144

DEDICATION

I would like to dedicate this book to my mother, Mildred E. Jenkins, who believed enough in me to send me to art school.

To my brother, Phil Jenkins, who taught me not to be afraid to be different.

And to Jack Koers who taught me how to "fly with the eagles."

ACKNOWLEDGEMENTS

Thanks to Phil Myer for helping me write this book.

To Don Gerdts, from KOCE Channel 50, who believed in a cowboy who painted flowers, and put me in my first television show, "Magic of Floral Painting" on P.B.S.

I would also like to thank Mr. Dennis Kapp, President of Martin/F. Weber Company and publisher of this book.

MEET THE AUTHOR

Gary Jenkins lives in Cherry Valley, California with his wife and three children. Although he has a busy, dedicated life as an artist — he has hosted three public television (PBS) series: **Magic of Floral Painting, Magic of Floral Painting II,** *and the soon to be released* **Magic Brush of Gary Jenkins***, featuring landscape, animal, clown, and floral painting — he still maintains a garden and an orchard and finds time for long walks in the country.*

Gary was born in New York and moved with his family to Sarasota, Florida when he was twelve. It was then that he discovered his talents as an artist; he graduated with honors from the Ringling School of Art. He then moved to California and after working as a keyline artist for a greeting card company and in many capacities for an art supply company, successful sales of his artwork allowed him to become a fulltime artist, that which he enjoys most.

Gary has traveled nationwide for over twenty years teaching art seminars and workshops. He has painted a wide range of subject matter demonstrating the true scope of his personality — gentle and bold, quiet and boisterous, pensive and buoyant. His affection and dedication to art is contagious, creating a following of people from all walks of life, young and old.

At the end of each painting, Gary steps back and asks himself if he did the best that he could — that's all that he asks of you. He wants you to enjoy landscape painting and find it a rewarding experience!

*Gary Jenkins — host of the television series', **Magic of Floral Painting I** and **II** and **Magic Brush of Gary Jenkins.***

INTRODUCTION

The painting of landscapes can be an exciting, constructive, rewarding experience: the preparation of the canvas; the background providing a foundation for the painting; the variety of stroking techniques from which the basic form evolves; and the details, highlights, and accents which reflect the artist's personal impression of the painting.

Each day of your life can provide sources for subject matter for landscape painting. Open your eyes and study Mother Nature's deposits around you. Learn to see her elements in terms of color tones, texture, form, and the momentum created by all of the elements. Do this and your painting will become a treasured and rewarding piece of artwork.

Make an effort to understand the principles and materials that are presented in the beginning of this book; before you can paint successfully you must first master the use of the various media and the stroking techniques. Practice until you feel confident that you can successfully paint the strokes presented.

Each of the landscapes can be tailored to suit your own creative needs or experiences. Take history — your own or someone else's — and make it a piece of life long art. Your artwork is an expression of yourself; don't be rigid — let the world know who you are — SOAR WITH THE EAGLES!

Successful painting can only come with the use of quality products. Paints and brushes are the key supplies that you will purchase. Quality products cost more, but will result in less problems and disappointments while painting, allowing you to spend more time painting rather than fixing or replacing lower quality products. I use Permalba Oil Colors, Misty Colors, and my signature Jenkins brushes for the painting techniques taught in this book and I recommend them to you.

I prefer oils to acrylics because of the slower drying time of the oil based paints. In landscape painting there is a lot of blending and over-stroking which must be executed while the paint is wet. If you already use acrylics with confidence, you should have no trouble modifying my oil techniques to your painting.

With regard to brushes, consider the brush as a tool; if a brush is not properly constructed and is not made of superior materials, it cannot possibly be used for proper application of the paint. Your brushes must work with you, not against you. They are one of your most important tools.

PAINTS

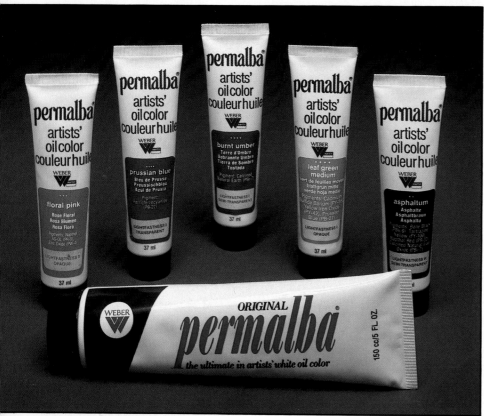

Permalba Oil Colors available in standard 37ml size studio tubes.

Permalba Oil Colors

The following is a complete list of Permalba Oil Colors. It is not necessary to buy the entire line; I only want you to familiarize yourself with all the color names.

Alizarin Crimson
Asphaltum
Bright Red
Brilliant Yellow Light
Burnt Alizarin™
Burnt Sienna
Burnt Umber
Cadmium Orange
Cadmium Red Deep
Cadmium Red Light
Cadmium Red Medium
Cadmium Vermillion
Cadmium Yellow Deep
Cadmium Yellow Light
Cadmium Yellow Medium
Cerulean Blue (Ultra)
Chrome Oxide Green
Cobalt Blue
Cobalt Violet Hue
Emerald Green
Flesh
Floral Pink™
Ice Blue
Indian Yellow
Indian Red
Ivory Black
Lamp Black
Leaf Green Light™
Leaf Green Medium™
Leaf Green Dark™
Lemon Yellow
Manganese Blue
Mauve (True Purple)
Naples Yellow Hue
Olive Green
Paynes Gray
Permanent Green Light
Phthalo Blue
Phthalo Green
Phthalo Rose Red
Phthalo Yellow Green
Prussian Blue
Raw Sienna
Raw Umber
Rose Madder
Sap Green
Terre Verte
Turquoise
Ultramarine Blue
Vandyke Brown
Venetian Red
Vermillion
Viridian
Yellow Citron
Yellow Ochre
Gold (Metallic)
Silver (Metallic)

I enjoy working with the Permalba Artists' Oil Colors for they have been tested and reviewed by the independent non-profit organization — The Art and Craft Materials Institute. All Permalba Oil Colors have been approved and are AP Non-TOXIC (Approved Product) with respect to both acute and chronic toxic effects for all reasonably foreseeable uses and misuses. The products bear the AP seal which is your assurance that these products are Non-TOXIC and are labeled with the best information available on how to enjoy them safely.

Permalba Oil Colors are vivid, intense, and exceptional paints for any type of canvas painting. They impart a smooth, buttery brushing consistency essential for successful painting. They are made of pure pigments ground in purified and refined oil to a satisfying buttery consistency that gives superior brush response.

Each tube label carries pigment identification, light-fastness ratings, opacity - transparency information, and vehicle or binder information for convenient reference.

All Permalba Oil Colors are available in standard 37ml size studio tubes and popular colors are sold in 11ml and 150ml tubes.

Original Permalba White is uniquely reliable for superior quality and performance. The exclusive blend of titanium and other pigments results in an outstanding, rich, creamy white oil paint: it yields the tints of color value and exceptional brilliance like no other white. Original Permalba White is available in 11ml, 37ml, and 150ml size tubes.

Permalba Misty Grey

I find Permalba Misty Grey an excellent basetone for landscape background surfaces. Mixed with a little Cerulean Blue, Burnt Umber, and other colors, it provides soft, cool tones essential when painting landscapes. It lends to superior tones when blending with the wet-in-wet technique and used alone or mixed with Permalba White it produces an effective tone for highlighting or subtle accenting.

Because of its wide application, Misty Grey is available in a convenient 150ml size tube. Simply squeeze the required amount onto a palette paper pad and mix with desired colors or use alone in background painting. You will find that mainly large brushes will be required for the application of the Misty Grey.

Permalba Misty Colors

Permalba Misty Colors provide the subtle soft tones required in landscape painting. These elusive colors promote smooth tonal transitions and softer edges which render graceful paintings with pleasing momentum. These Permalba Misty Colors were developed for the unique technique of my wet-in-wet procedures. The colors are softer in tonal value, allowing you to use a larger variety of color in a given painting without the problem of garish qualities arising.

Each Permalba Misty Color has been toned with pigments to grey down the full color intensity. The colors, when mixed together or with other Permalba Oil Colors, create subtle nuances of tones never achieved before. The colors have been designed to be delicate enabling them to stay in the background. They are to be used as a second player; not the main character of the painting.

If you have not painted landscape scenes before, you will soon realize how important the aspects of these particular colors are to the finished painting. On the whole, a landscape scene fills the entire canvas plane — encompassing a lot of territory. If the use of full intensity color was applied throughout a given painting, you would clearly see how busy the painting would become.

Permalba Misty Colors are available in the following six colors: Misty Yellow, Misty Red, Misty Green, Misty Crimson, Misty Orange, and Misty White.

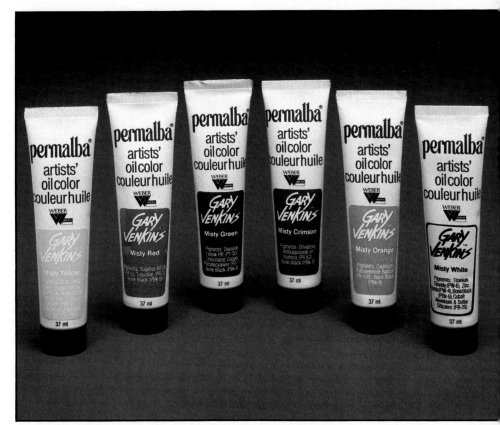

Permalba Misty Colors used in landscape painting.

MEDIUMS

Jenkins Happy Medium

Jenkins Happy Medium is an oil painting medium. It is a very pale medium, imparting brilliance while providing a thinner, pleasant working consistency to oil paints. Its effects provide a durable lasting surface. It is available in 74ml and 236ml bottles.

Jenkins Sta-Brite Varnish

Jenkins Sta-Brite Varnish is an odorless, light-bodied spray varnish for temporary protection of oil paintings. Sta-Brite brings out the color intensity and highlights the areas which tend to dry flat and dull. It dries fast and provides a non-yellowing gloss finish. It is available in a handy 355 gram size.

Turpenoid

Turpenoid is a thin, odorless, colorless turpentine substitute. It has the same painting and drying properties as turpentine, but is free of the characteristic strong turp odor. It is compatible with oil base colors. Turpenoid is also excellent for use in thinning varnish or solvents, cleaning paint brushes, and removing paint spots from clothing. It is available in several convenient sizes.

Damar Varnish

Damar Varnish is a natural picture varnish which gives a high gloss, strong protection, and increased brilliance to finished oil paintings. Apply this varnish six to eight months after the painting has completely cured. This is considered a final varnish, whereas the Sta-Brite Varnish is an interim varnish. Apply Damar Varnish with a soft hair varnish brush.

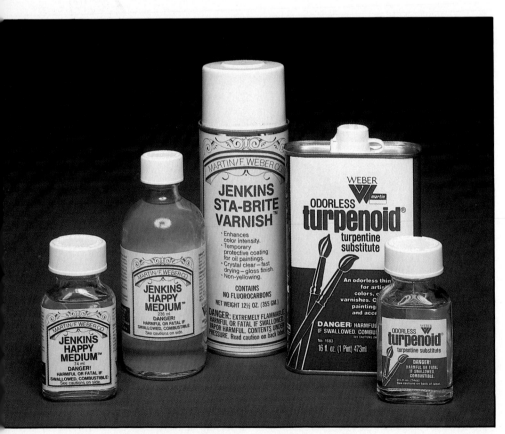

Jenkins Happy Medium, Jenkins Sta-Brite Varnish, and Turpenoid are useful as mediums, varnishes, and vehicles.

Brushes

The brush is one of the most important tools an artist must purchase; it is the key to the world of beautiful painting. When first learning to paint, you should never economize on inexpensive, poorly constructed brushes. With an inferior brush you will have difficulty in obtaining the desired results.

Fortunately, I was able to design a line of brushes that successfully meet the needs of canvas painting. The brushes were designed for my style of canvas painting and I hope that you will try them.

Brush Descriptions

The Jenkins Badger Flat is three-eighths inch wide and is used for painting little flowers and leaves.

The Jenkins Fan Brush is about one-and-one-half inches wide and looks just like a fan; the hairs are long in the center and shorter towards the edges. This brush is used almost exclusively for the placement of grass, but can sometimes be used for accenting.

The Jenkins Super Soft Blender comes in two widths — two-and-one-half inches and one-and-one-half inches. It is used for blending one color into another, for application of color on large areas, and for soften-

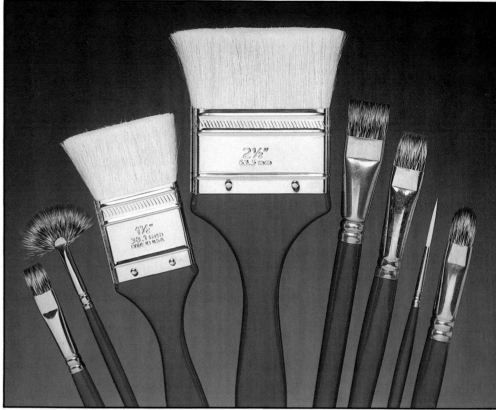

Gary Jenkins signature brushes are designed for large canvas painting.

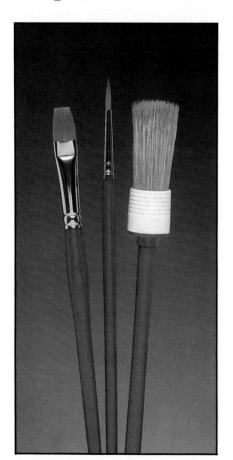

Special effect brushes

ing hard edges. The hairs on this brush are extremely soft; a characteristic which is necessary for the techniques taught in this book.

The Jenkins Badger Bright comes in two widths — one inch and five-eighths inch. It is excellent for laying in color on objects and backgrounds and for picking out highlights and accents. I use this brush in most paintings.

The Jenkins Liner is a brush made of fine long hairs which will pull to a fine point when properly loaded with the right consistency of paint. This brush is great when detail is necessary — twigs, stems, signatures — anything which calls for a tapered, narrow line.

The Jenkins Badger Filbert is one-half inch wide and has rounded corners. It is used primarily for painting small areas such as filler flowers.

The Jenkins Chisel Flat is three-eighths inch wide and is primarily used for color placement in smaller areas — rocks, posts, pickets. The brush also lends itself to small, circular motion.

The Jenkins Sable Round can be used for outlining and painting small objects such as leaves, and doors and windows of distant buildings. It is used in this book primarily for the placement of small daisies.

The Jenkins Tree brush is a white bristle brush, very stiff in form and seven-eighths inches in diameter. This brush is used almost exclusively for the placement of foliage in my landscape paintings.

MATERIALS

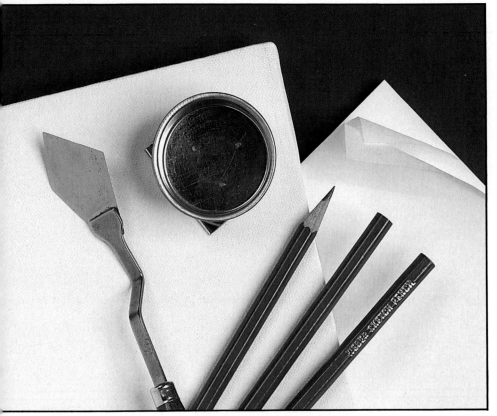

Canvas, Palette Knife - Cup - Paper, and Drawing Pencils are some of the basic materials.

Materials

You can not paint without the proper materials. Sure, you can use inferior paints, brushes, canvas, etc., the poor quality of the product will be obvious by the results. Even down to the miscellaneous materials, you should not skimp if at all possible. This is why I always have my beginning students start out with fine products. This will automatically cut out about half of the beginners initial problems.

I can not begin to stress enough . . . quality versus quantity . . . when purchasing your artist materials.

The following materials are subordinate to your paints and brushes, but sometimes small things can add up creating big problems. So when purchasing these items, look for quality products.

Canvas

The quality of the canvas is an important consideration for the painter. I prefer a canvas with a smooth finish. My techniques require a lot of stroking; a rough texture canvas would shorten the life of the brushes. Portrait smooth is an excellent grade of canvas to work on.

Palette Knives

Palette knives are available in various shapes and sizes. They are helpful in mixing colors and adding medium to the paints. In some of the landscape paintings, I have added highlights with a trowel shaped palette knife. The knife shown here is Martin/F. Weber's No. 22.

Medium Cup

The Jenkins Medium Cup is a perfect container for your Jenkins Happy Medium. It comes with a handy clip to attach to your palette.

Pencils

Drawing pencils are used in sketching and transferring the design onto the canvas. I suggest using a light lead pencil.

Palette Paper

A disposable palette paper pad is very convenient to use. The surface for an oil palette should not be too slick and not too absorbent. Pads are available in all sizes and shapes. I prefer a nice size palette with plenty of room to mix the colors (12" x 16" is ideal).

Transferring Designs

For all the paintings in this book, a pen and ink line drawing has been provided. This may be used to trace and transfer directly onto the canvas or as a reference when drawing.

For direct transferring trace the basic outline onto the tracing paper. Position the tracing paper on the canvas and tape it down. Slide a piece of graphite carbon paper between the canvas and the tracing paper and lightly go over the basic lines.

Some of you may find it of great help to project a photo slide onto the canvas and then trace the image. This is an excellent method, but don't get carried away with a lot of detail — just outline the images and key elements.

Mixing Medium Into Oil Color

The Jenkins Happy Medium was developed to mix with the oil colors to change the consistency of the paints when necessary. The more medium you add, the more fluid the paint will become. As a general rule, I always mix the oil paints with medium. There are three consistencies that I work with while painting: a mayonnaise consistency, a flowing consistency, and an ink-like consistency. I generally dip my brushes into the medium and then into the oil colors. You can also use a palette knife to do your mixing; I prefer to use my brush.

Dry Paint

Occasionally in this book, I mention using the oil color dry. By this I mean no addition of Jenkins Happy Medium — I do not mean to use dried oil color. This method is primarily used to highlight or indicate reflections when a crisp edge and no blending is desired.

Loading Your Brush

A properly loaded brush is essential for accurate painting. You will save yourself a lot of time if the brush is loaded properly. Begin by dipping the brush into Jenkins Happy Medium and then stroke the brush through a pile of paint, applying the paint to both sides of the brush. A properly loaded brush will have every hair saturated with medium and color. After you have stroked through the paint, move the brush to another spot on the palette and work the color into the brush. Remember to treat both sides of the brush.

Wet-In-Wet Technique

Most of my painting consists of this technique. By wet-in-wet I mean to work one color on top of another while both are wet. Many effects are created with this technique, most of which are not planned. Many successes in painting are by accident, so don't be intimidated by working with wet paints; relax and have fun.

Reflections

Reflections are a necessary addition to a beautiful painting. Hints of color from the main subject are placed in the foreground area, creating a harmonious feeling.

Color is applied with the Jenkins Badger Bright in quick, short, downward strokes. The edge of the brush is then zigzagged through, breaking up the stroke direction of the reflection colors.

Reflections should be placed below the subject in the foreground area and should not be extended too far.

BASICS

Criss Cross Stroke: *Photo Series 1*

This stroke is mainly used in color application to large areas. I use this stroke a lot when applying backgrounds. When using this stroke, the paint should have the consistency of mayonnaise.

Use the Jenkins Badger Bright to stroke the color onto the canvas. Think of forming X's when you are painting and build layers to form an opaque area on the canvas. Blending colors is easily achieved with this stroke.

Foliage Stroke: *Photo Series 2*

With the Jenkins Tree brush, hit the canvas with flush strokes; all the hairs of the brush hitting the canvas at the same time. When creating foliage, you generally use a series of color, usually beginning with the dark tones, followed with medium and light value tones, to build the dimension of the foliage. The foliage stroke can also be created with the Jenkins Super Soft Blender for a slightly different effect. See the last photograph in this series.

Daisy Stroke: *Photo Series 3*

The push pull stroke used here is a fundamental stroke. Learning it will help you to develop proper brush control. If you practice and master this stroke you will have more confidence when attempting other brush strokes.

Use the Jenkins Sable Round fully loaded with paint of a flowing consistency. Touch the brush to the surface, apply pressure, drag, pull and lift up quickly. This should taper the petal to a point. The stroking should be done quickly and without hesitation.

Texture Stroke: *Photo Series 4*

With the Jenkins Badger Filbert apply short, quick, choppy strokes. Develop layers of color, starting with the dark tones, working to moderate tones and ending with highlights. This textured surface is used frequently, but not exclusively, for the color application to tree trunks and bark.

Grass Stroke: *Photo Series 5*

Placement of grass in landscape painting has numerous functions: it is used for balance and as a filler, and it helps to *hold down* trees, posts, buildings, etc. so that they don't *float around.* Use the Jenkins Fan brush, dipped in Jenkins Happy Medium, and hit the canvas with an upstroke, quickly flipping the tip of the brush. Begin in the foreground with taller grass and work your way to the background with shorter strokes, fading the grass by

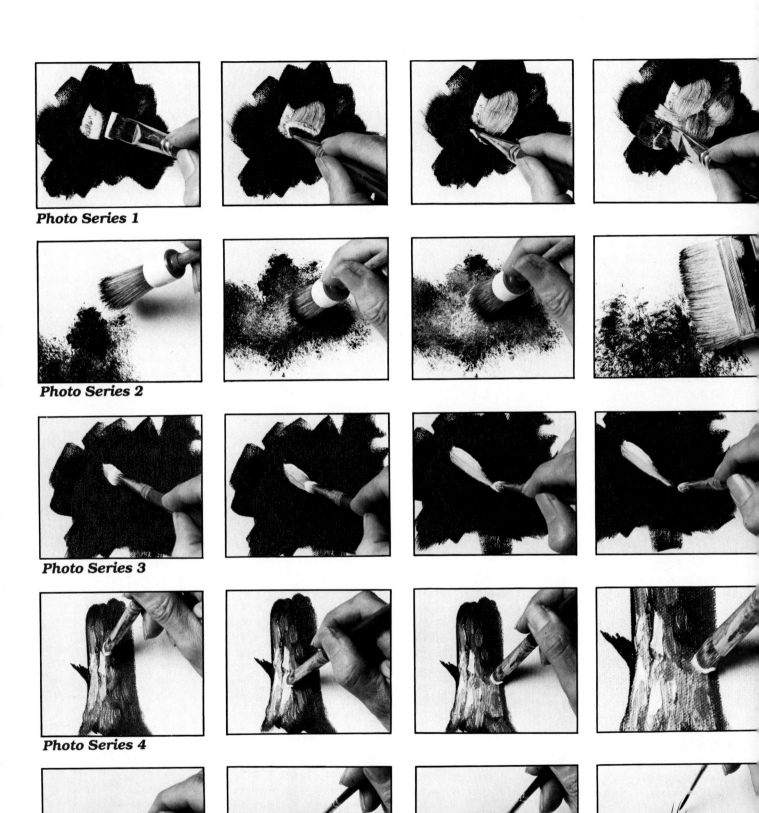

Photo Series 1

Photo Series 2

Photo Series 3

Photo Series 4

Photo Series 5

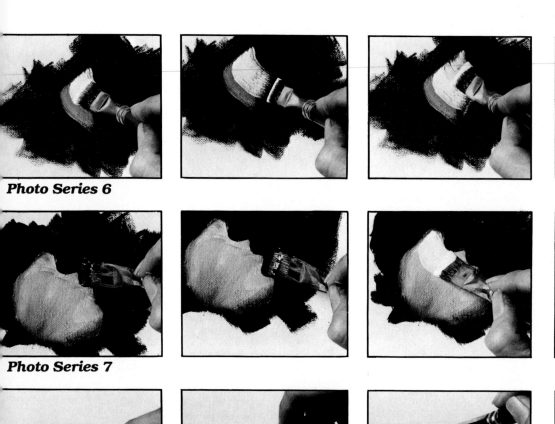

Photo Series 6

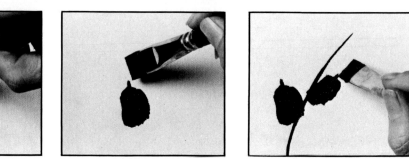

Photo Series 7

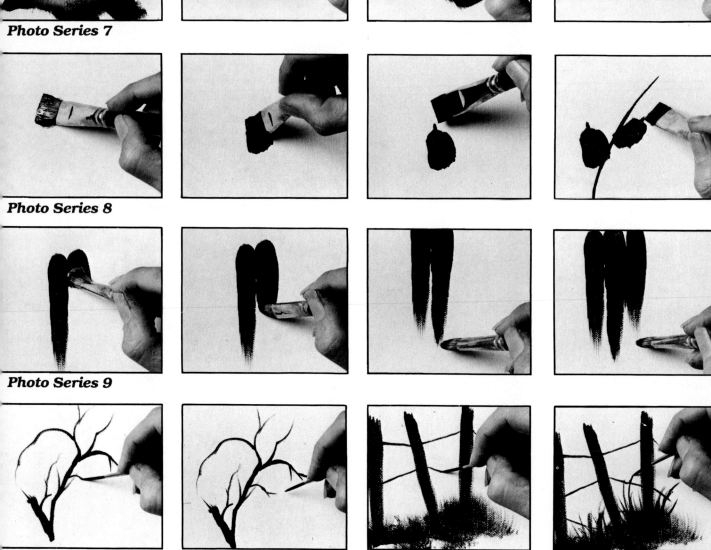

Photo Series 8

Photo Series 9

Photo Series 10

blending in the background colors. Accent the clumps of grass with line work with the Jenkins Liner.

Overlapping Stroke: *Photo Series 6*
This stroke is used in this book when painting the petals of the large flowers, but can also be used when applying base tones.

With the Jenkins Flat, overlap strokes about three-fourths of the way over previous strokes, creating a true blending of color.

Ruffled Petal Stroke: *Photo Series 7*
With the Jenkins Flat or Jenkins Badger Bright, create soft, ruffled edges around the petal by wiggling the sides of the brush around the edges, pulling in some of the background color to soften the edges. Accent the edges by placing darks along the outside line of the edge.

Wiggle Wiggle Leaf Stroke: *Photo Series 8*
Load the Jenkins Badger Bright with the desired color and begin to make an up-and-down movement, wiggling the brush as you do so. This will form the basic oval shape of the leaf. Once you have formed the basic shape, lift the brush up to the chisel edge and stroke out to form a small tip on the leaf.

This style leaf is very seldom painted by itself; it is usually on a thin stem with several other leaves. Stroke a thin stem with the chisel edge of the brush, and then stroke the wiggle wiggle leaves off of the stem.

Upward and Downward Strokes: *Photo Series 9*
When painting tree trunks, use the Jenkins Flat and begin at the base of the trunk, pulling the stroke towards the top of the painting, letting up on the pressure as you approach the top of the tree at the edge of the canvas. This should be done with one stroke when possible.

Downward strokes are done in reverse. Start at the top with pressure and then release the pressure as you work toward the bottom of the stroke.

Line Work: *Photo Series 10*
To accomplish line work in the landscapes — whether you are painting the tree limbs, fence posts, or grass — you will need to use paint with an ink-like consistency. Thin the desired color with Jenkins Happy Medium to a flowing consistency and load the Jenkins Liner good and full. Use only the point of the brush to create the fine lines.

LANDSCAPES

Over the centuries, landscape painting has allowed artists to observe natural settings and transform them into art that can be appreciated by future generations. Unlike still life and portrait paintings, a landscape painting offers a story: the artist's own, or one whose actors may remain unknown, but whose stage remains intact, only weathered by the passage of man, nature, and creature. In the following, you are offered a variety of landscape subject matter — sand dunes, streams and waterfalls, numerous trees and plant forms, barns, gates, fences — each provided with a feature role, frozen in a familiar time frame.

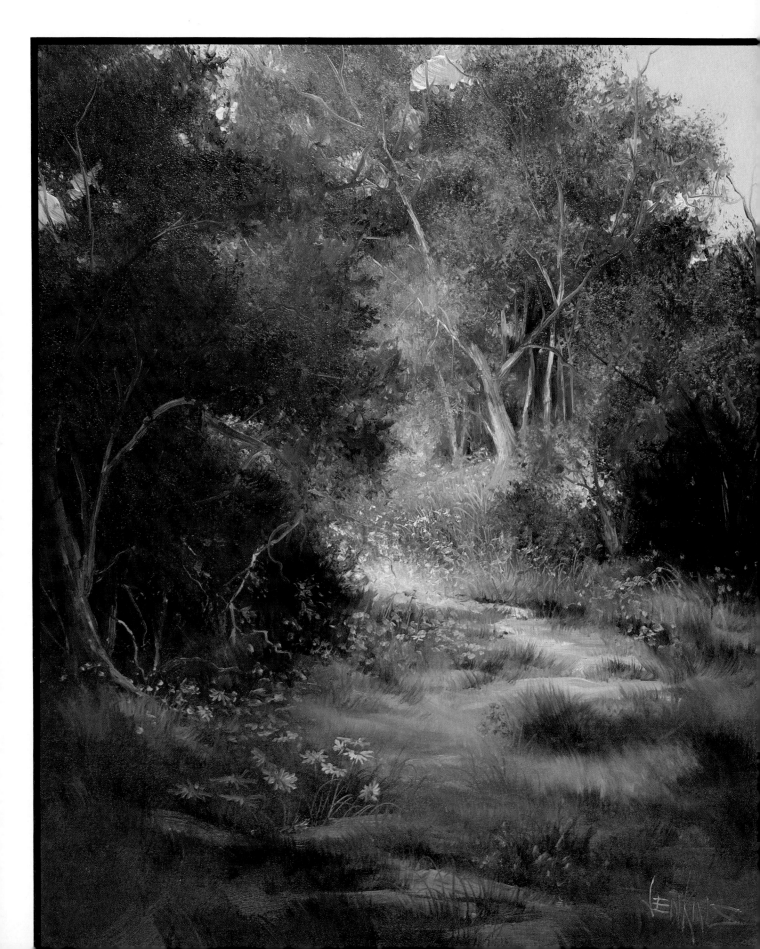

GARDEN'S GATE

The design of this gate is one most often found at farms and old homes around the country. Before modern times many gates and posts were of ornate design, often hand carved.

I found this particular gate near an old house in northern California. It was obvious that it had been there a long time. I photographed it and built a gate just like it with a fence of two hundred pickets — all carved by hand — one by one.

You can paint this same gate or you can go out into the country and photograph gates of your choice. The same feeling can be developed by painting other country objects — mailboxes, for instance.

Your painting will give you lasting pleasure in preserving a small slice of someone's history, perhaps your very own.

GARDEN'S GATE

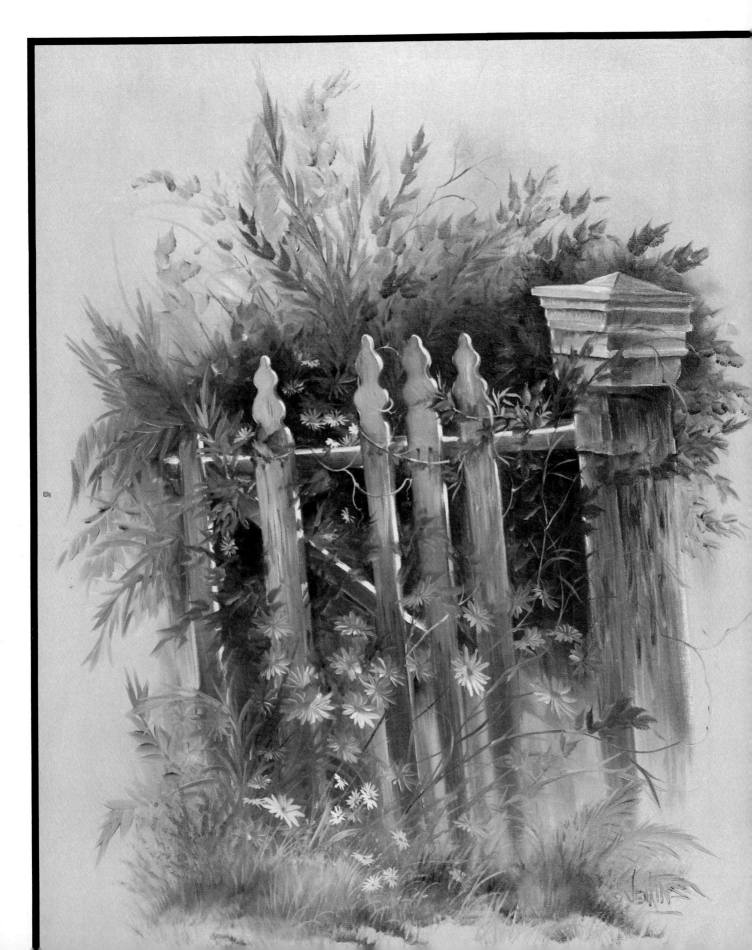

Garden's Gate

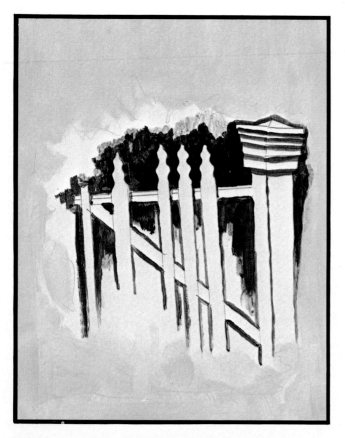

Stage 1

The background here is a mixture of Misty Grey, Cerulean Blue, and Burnt Umber. When applying the dark tones, be sure to leave the post and picket area white. Fade the dark tones into the background when approaching the bottom of the gate.

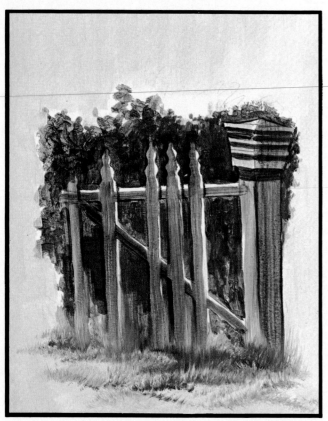

Stage 2

When placing the grass, it is important to have the brush "wet" with Jenkins Happy Medium. Use a mixture of Phthalo Yellow Green and Burnt Umber to create the grass. This grass will help to hold the posts down and cover the bottom of the gate. When applying the base tones to the boards be sure to use a thin mixture of paint and Jenkins Happy Medium.

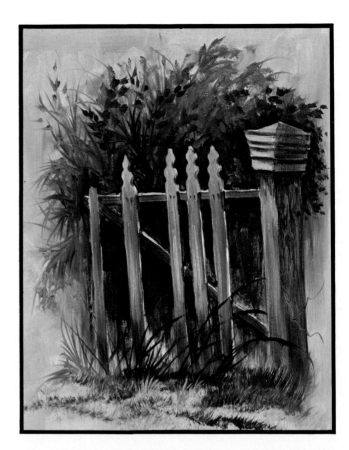

Stage 3

When creating the vines, attempt to add depth to the painting. Try to develop the painting from the center outward so that you do not crowd the edges. Pack the brush area full of ferns, vines, grass, and weeds. Add dark tones to the pickets, picking up shadows so that they are not too pronounced. Indicate knotholes and rust with these dark tones.

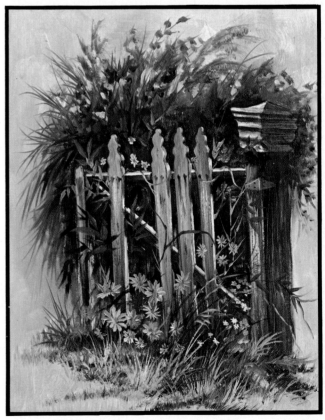

Stage 4

Accent the boards with a mixture of Permalba White and Cerulean Blue to help bring out the pickets. Take the dark tones and clean up the edges around the outside of the pickets. Add the vines and leaves in front of and around the pickets. Finish with placement of the daisies.

GARDEN'S GATE

Colors

Misty Grey	Burnt Umber
Cerulean Blue	Cadmium Orange
Burnt Sienna	Floral Pink
Permalba White	Ivory Black
Phthalo Yellow Green	Cadmium Yellow Light

Brushes

Jenkins 2½" Super Soft Blender
Jenkins 1" Badger Bright
Jenkins ⅜" Flat
Jenkins Fan
Jenkins Liner
Jenkins Sable Round
Jenkins Chisel Flat

Canvas Preparation:

On a 24 x 30 inch canvas sketch the fence post lightly with a light lead pencil. Do not apply a lot of pressure so no indentation is made into the canvas surface. If you have a photo slide of a gate, you can project it onto the screen and trace the pattern.

Color Placement: *Background*

Using a Jenkins Badger Bright, apply a mixture of Misty Grey, Cerulean Blue and Burnt Umber to the background. Use a criss-cross stroke on the post and picket area, as well as on the dark area behind and above the gate. Leave the post and picket area white.

Color Placement: *Darks Behind & Above Gate*

Blend a mixture of Burnt Sienna and Burnt Umber and apply to the dark area behind the pickets. Fade the darks into the background color toward the bottom of the gate, blending the darks into the Misty Grey mixture. Take care to avoid getting the dark color in the pickets and posts. Use the 2½" Jenkins Super Soft Blender to soften the edges into the background with a crisscross stroke. This keeps the edges misty to avoid sharpness.

Color Placement: *Grass*

Wet the Jenkins Fan brush with Jenkins Happy Medium. With a mixture of Phthalo Yellow Green and Burnt Umber, create the grass at the base of the gate. Remember to flip the brush with an upstroke only. This grass will hide the base of the posts and keep them from floating. To darken the grass add a little Burnt Umber, especially at the bottom of the pickets. Bring some of the Misty Grey background into the strokes. Add a few darks around the bottom of the grass area.

Color Placement: *Gate Boards*

For a base tone on the boards use the ⅜" Jenkins Flat. Apply a thin wash of Burnt Umber and Jenkins Happy Medium, about the consistency of a watercolor. Leave a border along the right edges of the boards where you will later indicate reflections of light. Use the edge of the brush around the top of the post so the guidelines won't be covered.

Color Placement: *Weeds and Vines*

Using the ⅜" Jenkins Flat or the Jenkins Liner which has been loaded very wet with Jenkins Happy Medium and a mixture of Phthalo Yellow Green and Burnt Umber, paint vines above the gate. Extend some into the background to create a feeling of depth. Don't crowd the edges.

With a mixture of Cadmium Orange and Burnt Sienna, create stems with leaves. For the stems use the chisel edge of the brush and then use the wiggle-wiggle-leaf stroke for the leaves. Bring some vines with leaves up to the top of the painting. Create more leafy ferns with the side of the brush; intermingle them with the vines and weeds.

Fill in the brush area — pack it full of ferns, leaves and vines. Mix styles and tones, picking up some color from the background.

Color Placement: *Accenting the Darks*

Using the Jenkins Chisel Flat and a mixture of Ivory Black with a little Burnt Sienna, deepen some of the dark areas behind the gate to keep this area dark and spooky. Be careful not to apply any dark paint to the pickets and post; roll the brush around the curves of the boards. This takes time and patience, but it will help to accent the leaves.

Color Placement: *Gate Post & Pickets*

Use a combination of Burnt Sienna and Ivory Black to darken the pickets. Remember that the base of the boards will be darker, indicating they have been stained with dirt splattered up from rainfall.

On the top of the post pick up shadows with this dark color: apply a horizontal stroke along the guideline, then carefully brush it down. Darken the shadow, if necessary. Don't get too tight with the shadows. Bring the dark down the post. Use the side of the brush to indicate knotholes and the edge to texture the boards. Place a little dark under the hinge to show where the rust has stained the wood.

With the Jenkins Fan brush bring some grass up over the bottom of the boards.

Color Placement: *Accenting*

Mix a bit of Permalba White and Cerulean Blue and using a dry Jenkins Flat, add light areas where the wood may have been bleached out. This will help to bring out the pickets.

Use a Jenkins Flat with a chiseled edge to apply a mixture of Permalba White and Jenkins Happy Medium to the vertical edges of the boards to indicate reflections. Add more medium if the brush is dragging. Highlight the areas indicated. If this is difficult, use a pointed sable brush.

Take your darks and cut back in and clean up the edges. Use some Permalba White and Burnt Sienna to touch up the post. You can also accent with Ivory Black and Burnt Sienna, remembering the shadows.

You can paint nails by making a dot of Burnt Sienna and Burnt Umber and streaking the point to show rust stains.

For added texture use a wadded paper towel, dabbing it onto the surface and then hitting it lightly with a Jenkins Super Soft Blender.

Color Placement: *Vines & Weeds*

With the side of the Jenkins Chisel Flat and some dark color, paint vines in front of the gate. Use a mixture of Phthalo Yellow Green and Permalba White to paint vines and leaves growing between the pickets and around the gate. With a combination of Phthalo Yellow Green and Burnt Umber and using the Jenkins Liner, paint a vine weaving around the pickets. Add leaves with the Jenkins Liner, keeping the vines loose and free.

Add leaves in front of the post, remembering that some are in shadows. For warmer shades of leaves use a mixture of Cadmium Yellow Light, Cadmium Orange, and Phthalo Yellow Green; for cool colors use Cerulean Blue and Permalba White, especially for the ferns.

Color Placement: *Daisies*

With the Jenkins Sable Round and Permalba White, begin painting the daisies. Use a push-pull stroke so that the petals taper, picking up some of the background color. With Cadmium Orange put a dot in the center of the petals. Vary the colors of the daisies with a Floral Pink and Permalba White mixture. Vary the positions and directions of the flowers.

Finishing:

Sign your name using the Jenkins Liner and thinned paint. Let your paint dry thoroughly. After it is dry, apply several coats of Jenkins Sta-Brite Spray Varnish to bring out the color intensity.

The following graph has been provided to enable you to enlarge the design. Increase the line graph double or more in size and sketch the design using this drawing as a guide. Do not feel you must copy it exactly — for you are the artist — create your own painting in the process.

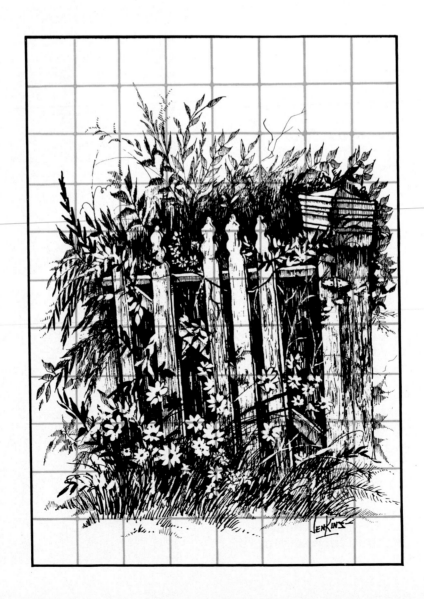

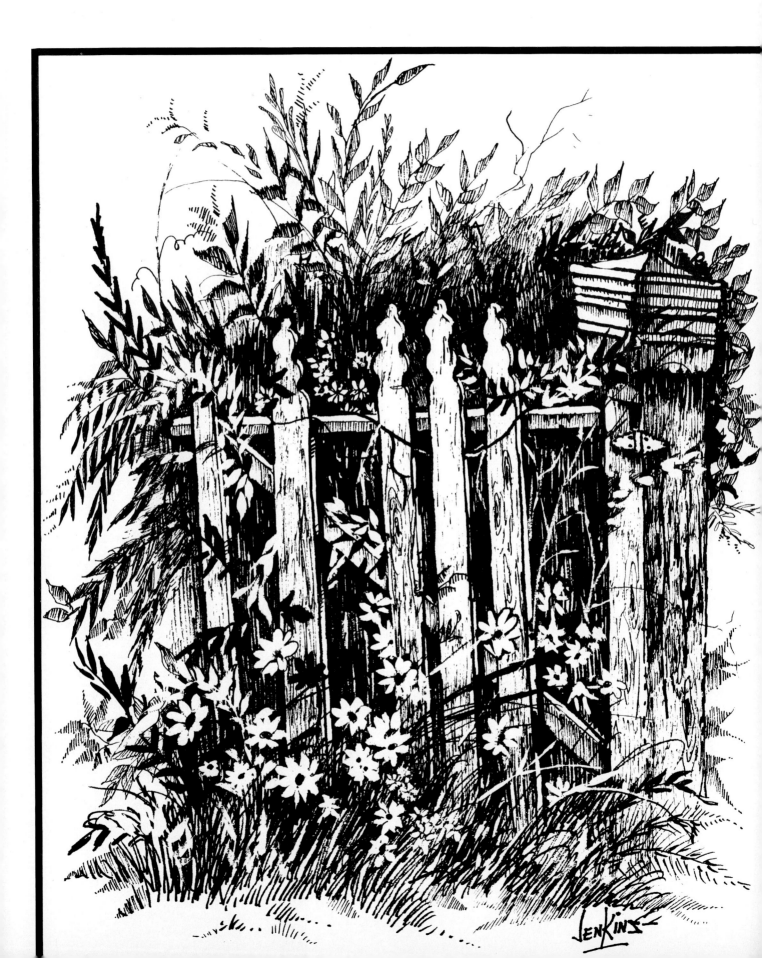

COUNTRY BARN

To get a feel for country landscapes, treat yourself to a day in the country. Observe the earth tones, along with nature's own blending and highlighting. You'll develop a sense of the effect of light, and you will also note that little detail work is necessary to develop this type of landscape painting.

This country scene is a relatively simple picture to paint. The barn in the background requires very little detail since it sits so far back. The scene is in monochromatic earth tones so there is a lot of blending of colors. If you would like to add more detail, you can add a wagon or mailbox or anything that might fit in, without cluttering the picture. It helps to keep all the objects in a landscape in the same time frame — you wouldn't want a sparkling new mailbox sitting in the foreground with the weathered barn behind it.

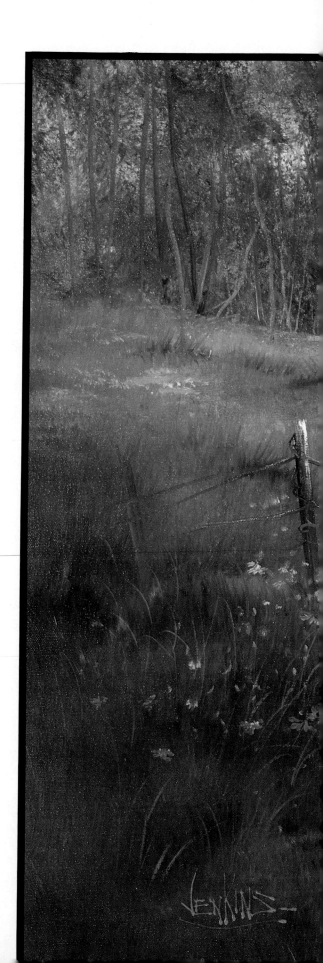

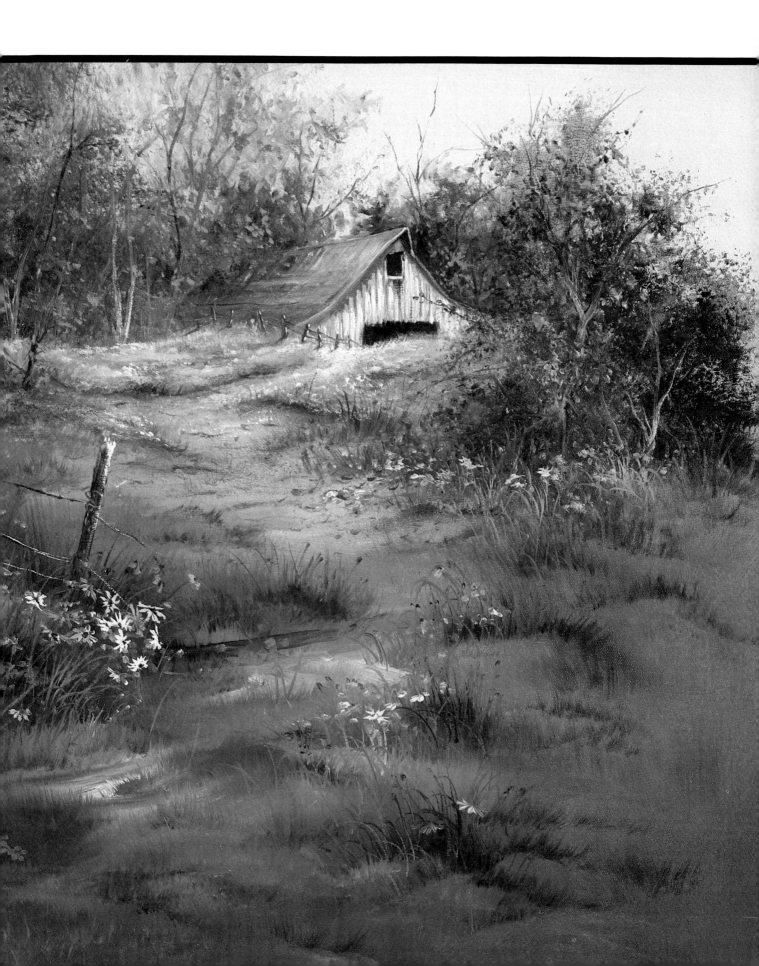

Colors

Misty Grey	Misty Green
Cadmium Orange	Cadmium Yellow Light
Cerulean Blue	Floral Pink
Burnt Sienna	Raw Sienna
Burnt Umber	Yellow Ochre
Permalba White	

Brushes

Jenkins 2½" Super Soft Blender
Jenkins Tree brush
Jenkins Liner
Jenkins ⅜" Flat
Jenkins Fan
Jenkins Sable Round
Jenkins Chisel Flat

Canvas Preparation:

Sketch this country scene on a 20 x 24 inch canvas with a light pencil. Do not apply a lot of pressure so no indentation is made into the canvas surface.

Color Placement: *Background*

With the 2½" Jenkins Super Soft Blender, paint the sky a mixture of Misty Grey with a touch of Cadmium Orange and Cerulean Blue. Come down and gradually add some Burnt Sienna and some Raw Sienna to this mixture. Paint the darks at the bottom with a mixture of Raw Sienna and Burnt Umber. Create the grass in the middle section with a mixture of Burnt Sienna and Burnt Umber, using an upstroke and the 2½" Jenkins Super Soft Blender. Keep the edges soft.

Color Placement: *Trees*

Create the foliage at the top of the painting by hitting the brush into the canvas. Use a mixture of Yellow Ochre and Raw Sienna and a dry Jenkins Tree brush. Hit the canvas with the brush to create leaf foliage. Add darker leaves with mixed Burnt Sienna and Raw Sienna and use straight Burnt Sienna for the darks. Work your way toward the left upper corner with Burnt Umber and Burnt Sienna. Accent the leaves with a mixture of Burnt Umber and Cerulean Blue. With the 2½" Jenkins Super Soft Blender, work some of the grass back in with Yellow Ochre.

Go in and pick out the trunks and branches with the Jenkins Liner and a mixture of Raw Sienna and Burnt Sienna. Darken some of the trunks with Burnt Umber. Flip up some of the grass below the trees using some Yellow Ochre mixed into the Raw Sienna and Burnt Sienna.

Blend the area with the 2½" Jenkins Super Soft Blender to tie it all in. With the Jenkins Liner add a few leaves on the lighter side of the trees for an accent.

Accent the light areas with a mixture of Yellow Ochre and Permalba White. Use Burnt Sienna for the darker areas. For the leaves on the left, use the Jenkins Tree brush and apply a mixture of Misty Green and Burnt Umber with the same hitting stroke you used before. With the Jenkins Liner and Burnt Umber, shoot some trees into this area. Accent the trees in the shadow area by picking up highlights with Cerulean Blue and Misty Grey. You can also accent the grass in the front of the trees with this color, then blend it in with the 2½" Jenkins Super Soft Blender.

Color Placement: *Barn*

Using the Jenkins Liner and Burnt Sienna, sketch in the barn. With Burnt Umber, a touch of Sienna, and the Jenkins Chisel Flat paint the roof of the barn, making it darker toward the back. To make the front of the barn lighter, use a mixture of Misty Grey and Burnt Umber. Try to develop a feeling of the boards.

Use the Jenkins Sable Round and Burnt Umber to paint the door and window. Also paint the hood extending from the roof. Place the shadow areas under the eaves. With Burnt Umber lightly indicate the boards in the front, bringing some of them out a little darker.

Remember this barn is pretty far back so you don't have to add a lot of detail. Use Misty Grey to accent the boards. Darken the doors with a mixture of Misty Grey and Burnt Umber and indicate a little bit of stain on the roof. Use the side of the brush to indicate a few boards on the roof.

Accent the roof with Cerulean Blue and Permalba White. You can use a little Yellow Ochre for additional highlighting of the roof. Use Burnt Umber to accent the front of the barn and Misty Grey to lighten up some of the boards.

Color Placement: *Leaves Behind Roof*

Trees will help to frame the barn so it doesn't stand alone. With the Jenkins Sable Round and a mixture of Burnt Umber and Burnt Sienna, dab behind the roof to indicate leaves. Add this same rust tone to the roof for accenting. Hit with the 2½" Jenkins Super Soft Blender to soften the edges.

With Burnt Umber darken the back of the roof so it will fade away into the background trees, adding more depth to the picture. With an upstroke bring some of the grass back over the barn, using the 2½" Jenkins Super Soft Blender.

Color Placement: *Path*

Take the Jenkins Flat and some Misty Grey and bring the path down into the foreground, picking up some of the background color. Lay the path in roughly with patches of color off to the sides.

With the Jenkins Fan brush use a mixture of Burnt Umber and Burnt Sienna to place grass around the edges of the paths. This will set the path down and with your brushwork, you can create little hills. Use short strokes in the background and higher ones in the foreground. Let the grass fade away toward the edges. Sharpen the darks and accent the lights.

Using the Jenkins Liner and a mixture of Burnt Sienna and Burnt Umber, pick out some blades, looking for a variety of shapes in the grass. Don't put too many in, you don't want to clutter the painting. You can accent some of the blades with Raw Sienna.

Color Placement: *Fence Posts*

These fence posts look as though they have been here a while so you don't want to line them up straight. Use the Jenkins Liner and Burnt Sienna to put the posts in and then wrap wire around them with a very fine stroke. Let the wire fade away in certain areas. With Burnt Umber bring in the grass around the bases of all the posts.

Color Placement: *Flowers*

Use the Jenkins Liner to place in the flowers. You can use Cadmium Yellow Light alone or mixed with Cadmium Orange, and also a mixture of Floral Pink and Permalba White. Accent the flowers with a mixture of Permalba White and Cadmium Yellow Light. Dab the flowers around the fence posts and add some flowers on the other side of the path. Scatter even more up the path toward the barn.

Finishing:

Sign your name using the Jenkins Liner and thinned paint. Let your paint dry thoroughly. After it is dry, apply several coats of Jenkins Sta-Brite Spray Varnish to bring out the color intensity.

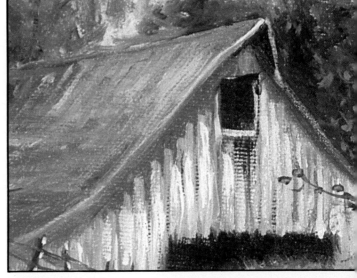

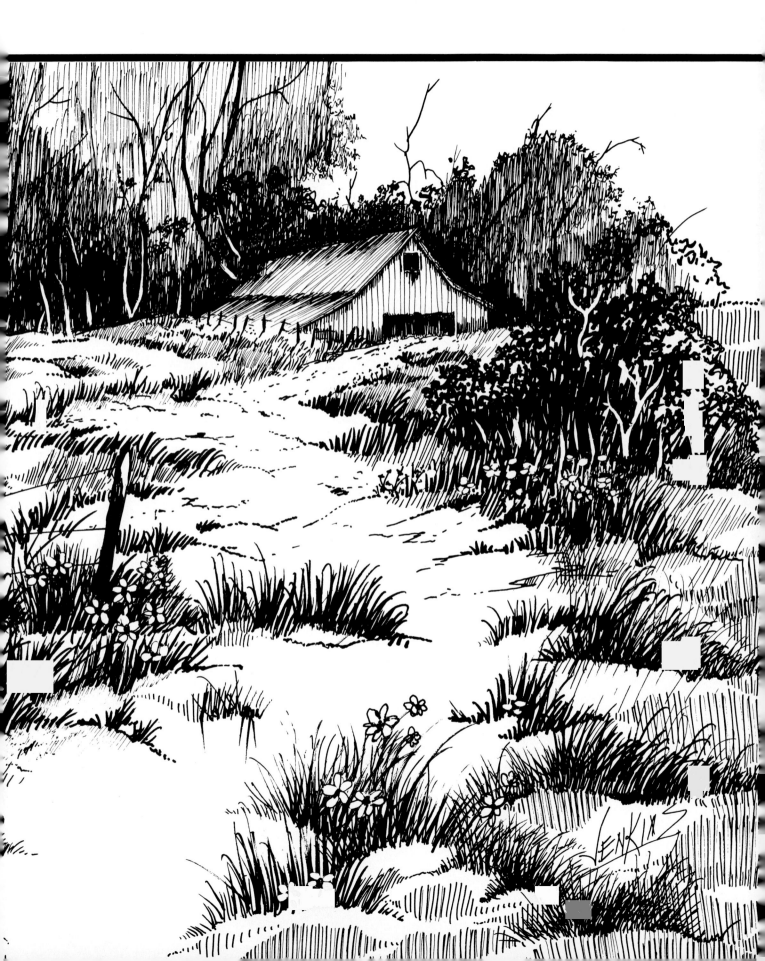

FLOWING FREE

Lucky are those who have had the experience of resting near a stream filled with natural falls — a reminder of nature's everpresent cycle. This painting is filled with the contrast of warm earth tones and the cool tones of the water, resulting in a quiescence easily resurrected with memory.

Most of the designing and developing of this scene takes place while you are painting. Layout of the background colors will determine the path you choose for the stream. Remember the path of the water is determined by the surrounding elements. Allow the paint to flow on freely — you are painting a scene of nature — do not make it stiff and unnatural. Soar with the eagles!

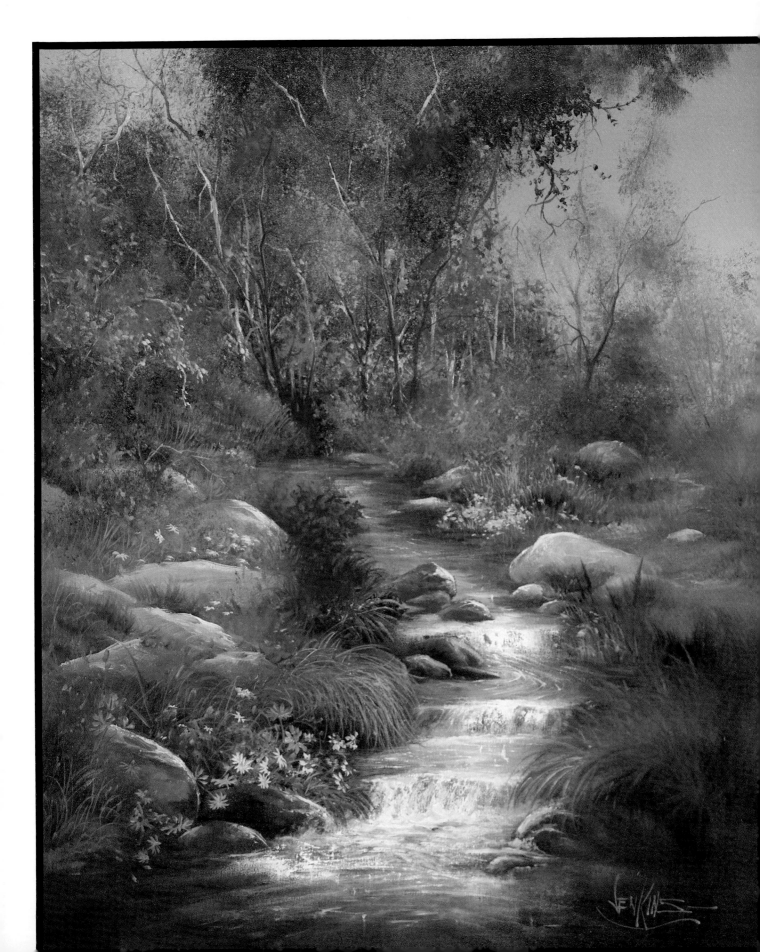

Stage 1

Sketch in the rocks lightly to locate the stream. A lot of detail is not required at this point; just develop a feeling for the balance of the painting. The sky is applied with light tones: Cerulean Blue with a touch of Burnt Umber. The dark tones in the stream and in the foliage help to create contrast against the sky and flowing water.

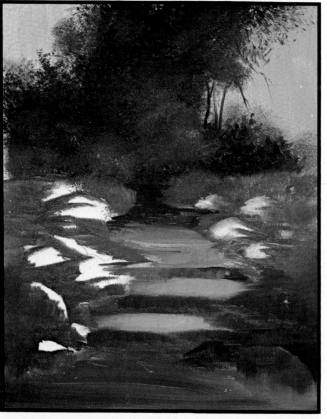

Stage 2

At this point, the rocks are further developed as is the stream. Add the bushes under the trees with lighter tones created with a mixture of Yellow Ochre and Phthalo Yellow Green. Some edges should be soft while others are hard and distinct. You can begin filling in the grass and sand areas with the Jenkins Fan brush.

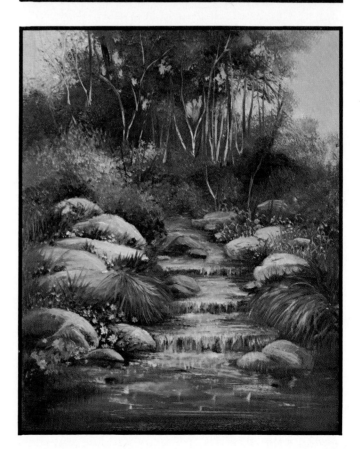

Stage 3

Now you will add the darks at the top and bottom of the stream. The colors used here come from a combination of Cerulean Blue and Mauve. The Jenkins Fan brush is used again for the creation of the waterfalls. Be sure to indicate the movement of the water, spilling over the rocks. The water can be highlighted when you are finished.

Stage 4

You can now begin to shape the rocks more firmly. Some of the rocks can blend into the background while others can have harder edges. The Jenkins Super Soft Blender can be used to soften the edges. Use the Jenkins Fan brush to settle the rocks and then finish with highlighting and placement of the daisies.

FLOWING FREE

Colors

Burnt Umber	Burnt Sienna
Raw Sienna	Permalba White
Cerulean Blue	Yellow Ochre
Misty Alizarin	Misty Grey
Cobalt Blue	Misty Green
Phthalo Yellow Green	Mauve

Brushes

Jenkins Fan
Jenkins 2½" Super Soft Blender
Jenkins Chisel Flat
Jenkins Liner
Jenkins Tree brush

Canvas Preparation:

Lightly sketch the path of the stream on a 20 x 24 inch canvas, being careful not to leave an indentation in the canvas surface. Most of the detail in this picture will be done while painting.

Color Placement: *Background*

The color placement of the background is quite extensive for this painting. You will be laying the groundwork for the stream placement and the surrounding rocks.

Begin with the sky, using a mixture of Misty Grey, Cerulean Blue and a touch of Burnt Umber. Apply it with a 2½" Jenkins Super Soft Blender. As you come down the canvas surface, lighten the mixture with some Yellow Ochre to warm it up. Stop about 2/3 of the way down the canvas.

With the Jenkins Chisel Flat lay the darks in the stream area, picking up some of the color from the sky. Use a mixture of Cerulean Blue and a little Burnt Umber with Jenkins Happy Medium. Use this color for the tree trunk and apply it with the Jenkins Liner.

To create the tree foliage use the Jenkins Tree brush. Mix some Burnt Sienna and a touch of Cobalt Blue and Jenkins Happy Medium and literally hit the brush straight into the canvas. This area should be very dark for contrast against the sky. Add a little Misty Green as you work toward the left side of the tree. Let some of the sky show through here and there.

Add little branches to the tree with Burnt Sienna and Burnt Umber, using the Jenkins Liner. Thin the color with Jenkins Happy Medium for a flowing consistency for the line work.

Take the Jenkins Tree brush and accent the foliage with a mixture of Yellow Ochre and Cerulean Blue. On the light side add a little more Yellow Ochre to highlight the leaves. Use Raw Sienna mixed with Burnt Sienna to add a reddish tone toward the bottom of the leaves.

Add some detail to the leaves on the edges of the tree with the Jenkins Liner.

With the Jenkins Tree brush add bushes under the tree. Use a mixture of Yellow Ochre and Phthalo Yellow Green. Some edges should be softly distinct while others will fade into the background. With the Jenkins Chisel Flat bring some of this color into the water to indicate reflections. With Burnt Sienna and Raw Sienna bring some of the lower edges of the leaves down with short vertical strokes. To soften the outside edges of the bushes, load the Jenkins Fan brush with some Yellow Ochre and apply to these areas.

Fill in the stream with a base coat, using the Jenkins Chisel Flat and a mixture of Burnt Sienna and Cerulean Blue.

With Yellow Ochre, Misty Grey, and the Jenkins Fan brush, add sand on the shore. Blend in some Burnt Sienna with this mixture for the opposite bank. Applying this light color against the dark of the water will help to set the water down.

Fill in the grass area, using the Jenkins Fan brush and a mixture of Jenkins Happy Medium, Raw Sienna and Burnt Sienna.

Color Placement: *Stream*

Bring shadows into the water and grass areas, using the Jenkins Fan brush with Misty Grey and Mauve.

With Cerulean Blue and Mauve add the darks at the base of the stream for the waterfall. Use this color to darken the top of the stream.

Set a dark base tone for the rocks by covering the rest of the canvas with combinations of Mauve and Cerulean Blue, and Burnt Sienna and Raw Sienna.

Use Burnt Sienna and Cerulean Blue to darken the bottom of the canvas. This is a nice cool color against all the warm color at the top.

Color Placement: *Waterfalls*

With the Jenkins Fan brush and Misty Grey, create the horizontal edges for the falls, then "spill" the water over the rocks with downward strokes. Do not overwork this area. Blend the Misty Grey into the background colors to create a softer image, adding highlights here and there. Pull some grass over the edges of the stream. With the Jenkins Fan brush and a mixture of Burnt Sienna and Burnt Umber, flip in some grass on the banks. Use Burnt Umber and Cerulean Blue to create bushes and grass. The edge of the Jenkins Fan brush can be used to create interesting bush shapes.

Highlight the water and add sparkle with the Jenkins Liner, using a mixture of Permalba White and Misty Grey.

Color Placement: *Rocks*

Using the Jenkins Chisel Flat and a mixture of Raw Sienna and Cerulean Blue, create the shape of the rocks. Highlight with Yellow Ochre and Permalba White, pulling the edges down. Add reflections with a mixture of Cerulean Blue and Permalba White. Darken the rocks by blending them into the background colors. Let the paint set a little, then add some sparkle with Misty Grey and Permalba White. Blend these colors with the 2½" Jenkins Super Soft Blender to soften the edges.

With a touch of Raw Sienna in Permalba White, add some light rough rocks toward the tip of the stream. Drag in colors from the background. This will help to break up the grass area. On the banks of the light side of the stream, add Permalba White with Misty Alizarin to create the rocks. For the very distant rocks use a combination of Cerulean Blue and the Permalba White and Misty Alizarin. Pull up some grass around the rocks to keep them from floating around.

Color Placement: *Daisies*

With the Jenkins Liner and a mixture of Permalba White and a touch of Misty Alizarin, place some daisies around the rocks.

Finishing:

Sign your name using the Jenkins Liner and thinned paint. Let your paint dry thoroughly. After it is dry, apply several coats of Jenkins Sta-Brite Spray Varnish to bring out the color intensity.

The following graph has been provided to enable you to enlarge the design. Increase the line graph double or more in size and sketch the design using this drawing as a guide. Do not feel you must copy it exactly — for you are the artist — create your own painting in the process.

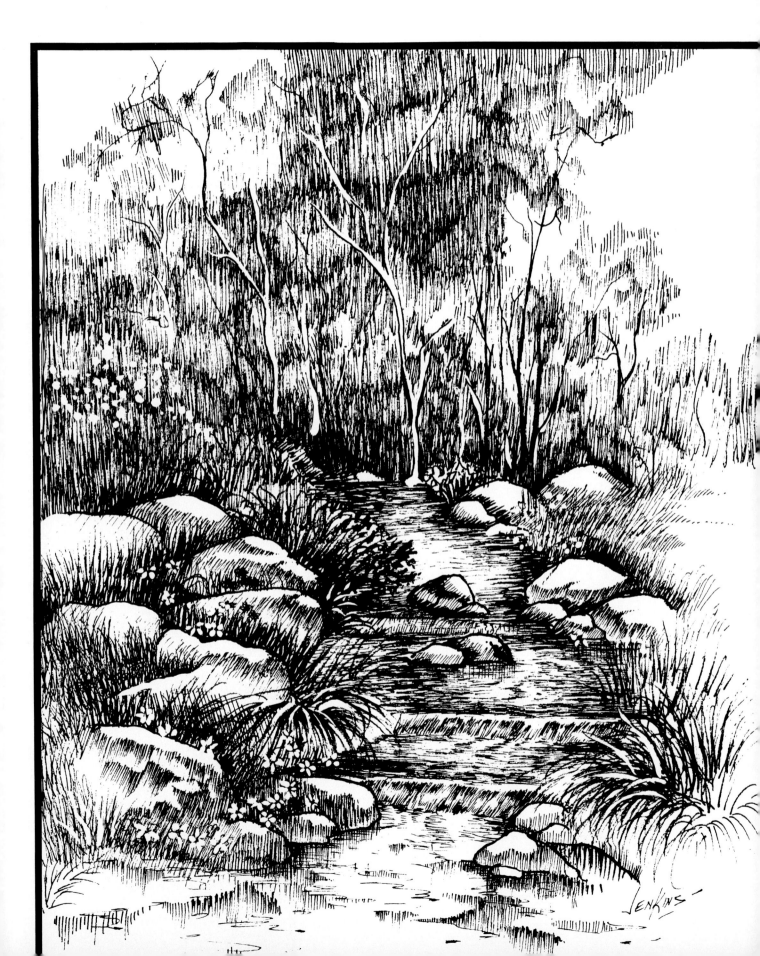

DESERT ENCOUNTER

In the West some people still believe that the thorns of the Jumping Cholla actually jump out and attack the passersby. Whether this is true or not, the flowers on this cactus certainly could startle an onlooker when they are in full bloom. The clusters of cream-colored petals with a hint of pink are a sharp contrast to the earth tones found in their natural environment.

This floral painting is more complicated than my previous floral paintings; each stroke does not produce an instant leaf or petal but carefully develops a blossom. Care and patience will help you to create a satisfying painting.

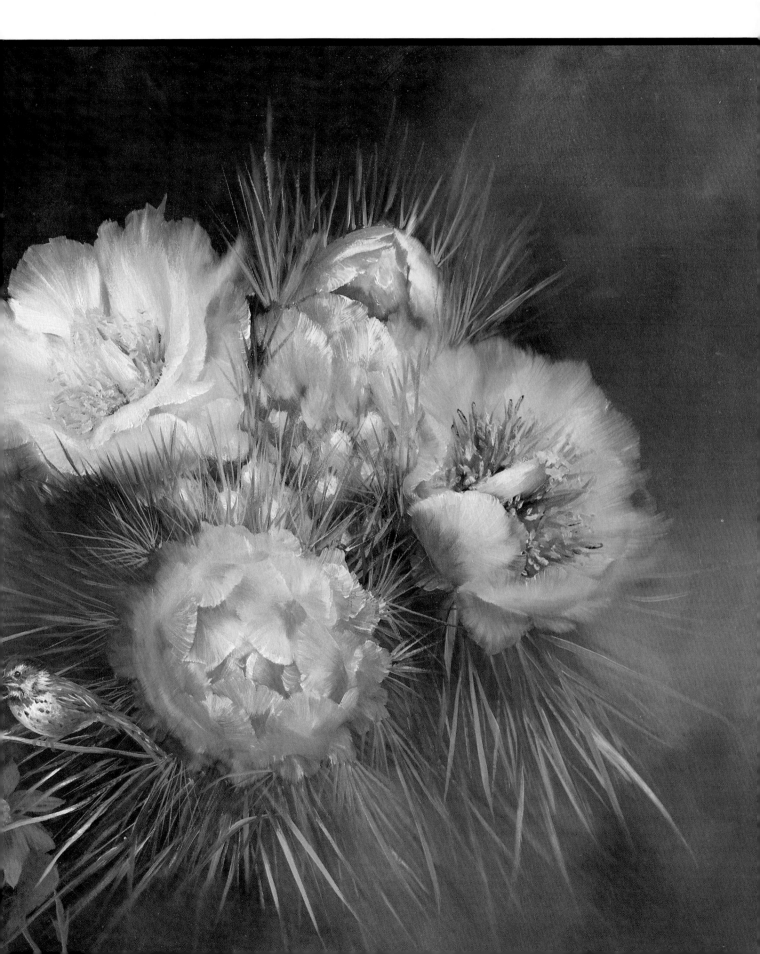

DESERT ENCOUNTER

Colors

Yellow Ochre	Raw Sienna
Indian Red	Burnt Umber
Ivory Black	Phthalo Yellow Green
Cadmium Yellow Light	Floral Pink
Cadmium Orange	Permalba White
Mauve	Misty Grey
Misty Crimson	Bright Red
Misty Green	Turquoise
Burnt Sienna	

Brushes

Jenkins Badger Bright
Jenkins ⅜″ Flat
Jenkins Liner
Jenkins 1½″ Super Soft Blender
Jenkins Chisel Flat
Jenkins Sable Round

Canvas Preparation:

Due to the intricate detail and placement of these flowers, it would probably be best to project this picture from a slide and trace it. If that is not possible, use a grid system to transfer the design to the canvas. The canvas size is 24 x 30 inches.

Color Placement: *Background*

With a Jenkins Badger Bright paint the background with crisscross strokes. Experiment with the colors, blending one tone into another for smooth transitions.

Begin in the top left corner with a mixture of Burnt Umber and Ivory Black. Work down with Yellow Ochre and in the lower left corner use Indian Red.

Moving to the right of the lower left corner, with Ivory Black and Yellow Ochre blend a mixture of Indian Red and Permalba White for the lower right area. With a combination of Yellow Ochre and Burnt Umber, add a little Indian Red as you work up to the upper right corner.

Work toward the center with the Burnt Umber and Ivory Black mixture. Blend the colors so no sharp edges are left.

Color Placement: *Thorns*

Paint the thorns with a combination of Yellow Ochre, Indian Red, and Burnt Sienna, using either the side of the Jenkins Flat or the Jenkins Liner. You can highlight the thorns with Cadmium Yellow Light and Permalba White. Don't paint too many lights or the painting will get too busy. With the Jenkins Super Soft Blender, soften the lines by blending them slightly here and there.

Color Placement: *Nodules at Base of Blossoms*

With the Jenkins Chisel Flat and a mixture of Phthalo Yellow Green and Ivory Black, form the nodules at the base of the blossoms. Create circular shapes with crisscross strokes to indicate texture.

Use Raw Sienna and Yellow Ochre to show a hint of nodules under the far right blossom. Fill in the centers with Cadmium Yellow Light on a dry brush, picking up background color and fading the edges.

With a mixture of Raw Sienna and Burnt Sienna and using the side of the brush, extend thorns from the nodules. Highlight the nodules with Permalba White. Accent with Phthalo Yellow Green and Ivory Black.

Color Placement: *Top Center Bud*

Misty Crimson will be used dry for the base tone. This Permalba color is a soft tone and flows easily without medium. Paint the areas indicated with Misty Crimson, using the Jenkins Flat. Add Cadmium Orange to accent the top with crisscross strokes. These darks are a structure for the blossom you will highlight later.

Use an overlapping stroke and Cadmium Yellow Light with a touch of Cadmium Orange to paint each petal individually. The petals should overlap. Paint only the edges of the petals coming around the sides. Note that at the bottom of the bud the petals are thinner.

With Permalba White and the Jenkins Flat, use short strokes to add texture to the petals.

Mix the Permalba White with Cadmium Yellow Light to highlight the petals at the top. Remember each petal has its own vanishing point and strokes should radiate from this point. Highlight the thorns above and around the bud. If the background is too wet, do this later.

Color Placement: *Top Left Blossom*

Start out with darks to create a sense of depth. With Ivory Black and Phthalo Yellow Green establish the darks in the center of the flower. For a creamy-colored base tone, thin a mixture of Permalba White and Ivory Black with Jenkins Happy Medium. Fill in the flower, staying away from the darks so you don't drag them in and make the base tone muddy. Pull in some of the background to soften the outer edges. This will also throw the bottom right edge into a shadow. Use the same base tone to carefully pull the darks in the center out into the petals.

With a mixture of Permalba White, Cadmium Yellow Light and Ivory Black, wiggle the brush around the edges to create a ruffled look. Pull some of the background into the edges to help tie the flower in. Add Phthalo Yellow Green and Cadmium Yellow Light to the Jenkins Flat and stroke the color on the petals, brushing out from the center to the edges throughout the flower.

Add a touch of a Floral Pink and Permalba White to the cream mixture to highlight the lower left portion of the flower and also to separate the petals. Indian Red is a good shadow color. Use it to help accent some of the darks and to add strokes to help the front petal fold over.

With a touch of Jenkins Happy Medium, Permalba White, Cadmium Yellow and Cadmium Orange, pick out the highlights. Stroke toward the center. Create the large petals on the left. Smooth edges as necessary, remembering to keep the brush wet with color and medium. When the edge of the petal bends down, stroke to the side. Remember to overlap strokes about three quarters of the way down on a given petal.

For the center of the flowers use a mixture of Ivory Black and Phthalo Yellow Green to indicate the stamens, accenting the darks. Use Phthalo Yellow Green and Cadmium Yellow Light for the tops of the stamens.

Highlight the flower with Floral Pink and Permalba White. Accent the stamens with Phthalo Yellow Green and Cadmium Yellow Light, using the side of the brush. With a very dry mixture of Cadmium Yellow Light and Permalba White highlight the center.

Color Placement: *Top Right*

Add darks to the center of the blossom as you did with the first flower. Pull the darks out with a mixture of Phthalo Yellow Green and Cadmium Yellow Light. Add more yellow as you work toward the edge. Apply color using the Jenkins Flat.

Mix some Mauve with Misty Grey and paint the petals, creating ruffled edges with the side of the brush. If you pick up darks, just blend them in. Leave a hard edge on the center of the front petals. Add some yellow to the Mauve mixture for the front petals. Put the center in with a mixture of Phthalo Yellow Green and Cadmium Yellow Light. Highlight with Permalba White so the center *pops out.* Accent with Floral Pink around the edges. It's always nice to accent color in a flower to make it a little bit brighter than it truly is. You can see this flower will be darker than the first one.

Use Misty Grey with a little medium to paint the petals. Remember to overlap the strokes and blend some of the edges into the background. Let the strokes flow down into the center of the flower.

As in the first flower, use a mixture of Ivory Black and Phthalo Yellow Green to pull out the stamens. You may be able to drag the darks out that are already there.

Color Placement: *Lower Bud*

Using the Jenkins Badger Bright, add a mixture of Burnt Sienna and Cadmium Orange to block in the dark lower half of the bud. Use Cadmium Yellow Light and a touch of Cadmium Orange to block in the upper half. To add darks to the bottom, blend in a mixture of Burnt Sienna and Burnt Umber.

With the Jenkins Chisel Flat take Misty Grey and paint diamond shapes in the center and pick little petals radiating from the center out to the edges.

To add excitement, accent the center with a mixture of Floral Pink and Misty Crimson. Highlight the petals with Permalba White on a dry Jenkins Flat. To highlight the thorns, use a mixture of Cadmium Orange and Permalba

White and the side of the brush.

Color Placement: *Daisies*

Wet a Jenkins Badger Bright with Jenkins Happy Medium and blend a touch of Burnt Sienna with Cadmium Orange. To form petals begin with the flat of the brush, then turn the brush and pull up to create the tapered petals. Keep the paint thinned with medium.

Highlight the petals with Cadmium Yellow Light and a touch of Cadmium Orange but do not bring them out too much; they are there to balance the painting, not to attract attention.

Place the centers with a mixture of Cadmium Orange and Burnt Sienna and highlight them with Cadmium Yellow Light.

Color Placement: *Daisy Leaves*

Use Permalba White and a touch of Turquoise and Burnt Sienna to add the leaves around the daisies. Darken them with Burnt Sienna and a touch of Misty Green and Burnt Umber.

With a mixture of Burnt Umber and Yellow Ochre form the stems. Bring some of the thorns over the tops of the daisies and between them.

Color Placement: *Desert Wren*

The wren is painted after the painting is dry. If you cannot sketch the wren, project a picture of it on the canvas and trace the outline of the bird with Misty Grey using a Jenkins Sable Round.

This time we are going to apply the lights before the darks. Add a dry mixture of Cadmium Yellow Light and Cadmium Orange and fill in the wren's body. Blend in some Bright Red and Cadmium Orange, without a lot of detail. Leave the eye blank.

With Burnt Sienna and Burnt Umber, begin painting the darks by rounding off the belly. Blend the darks into the tail. Add little feather strokes on the head. Take very dry Permalba White and blend it into the surrounding colors of the breast. Use a mixture of Misty Green and Permalba White and continue to round off the lower belly.

To indicate feathers on the breast, use short strokes with Permalba White. Burnt Umber and Burnt Sienna are used for the dark feathers on the breast and to accent the wing.

Highlight the eye with Permalba White. With Yellow Ochre curl strokes around the thorn for the feet and then darken some of the deep tones of the bird with straight Burnt Umber. Fill in some of the details as indicated using Cadmium Orange to accent the breast and feathers on the wing. Highlight with Permalba White.

Finishing:

Sign your name using the Jenkins Liner and thinned paint. Let your paint dry thoroughly. After it is dry, apply several coats of Jenkins Sta-Brite Spray Varnish to bring out the color intensity.

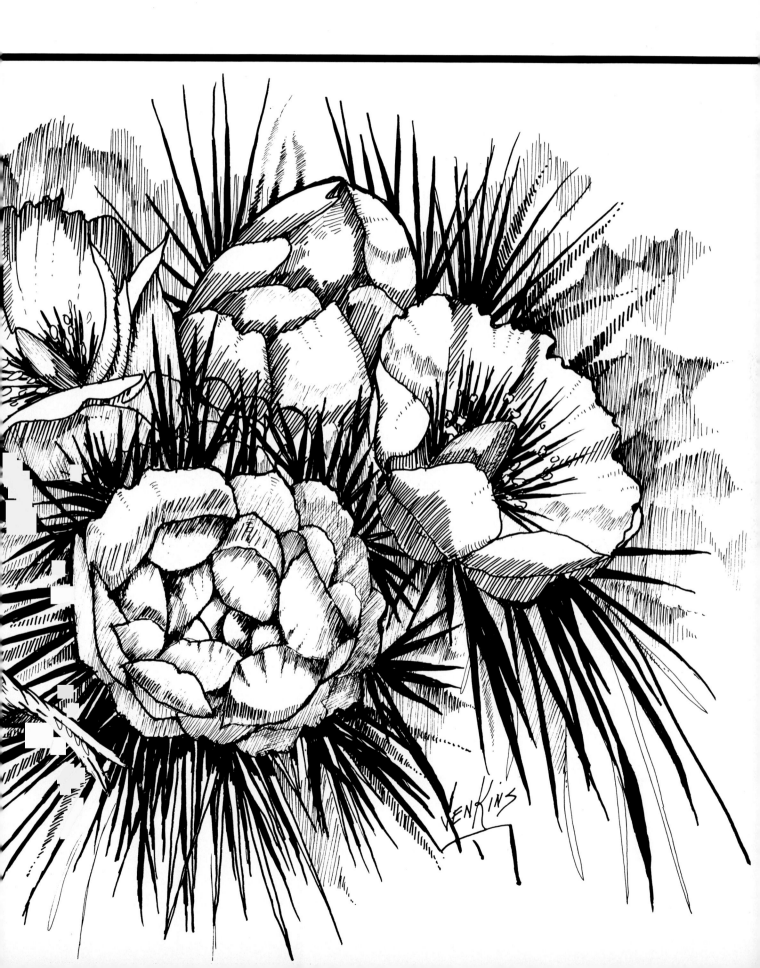

SUMMER BYWAY

Painting this scene will help you to study the ocean. If possible, visit the beach and observe the patterns in the sand, the pathways of the waves and the point where the ocean meets the sky; a horizon defined by similar tones and contrasting elements.

I put a fence post in this painting. Many other objects can be painted to reflect your personal recollections of the beach and ocean.

This painting will certainly help you to master the use of the Jenkins Fan brush. The strokes used are paramount in creating the dune grasses.

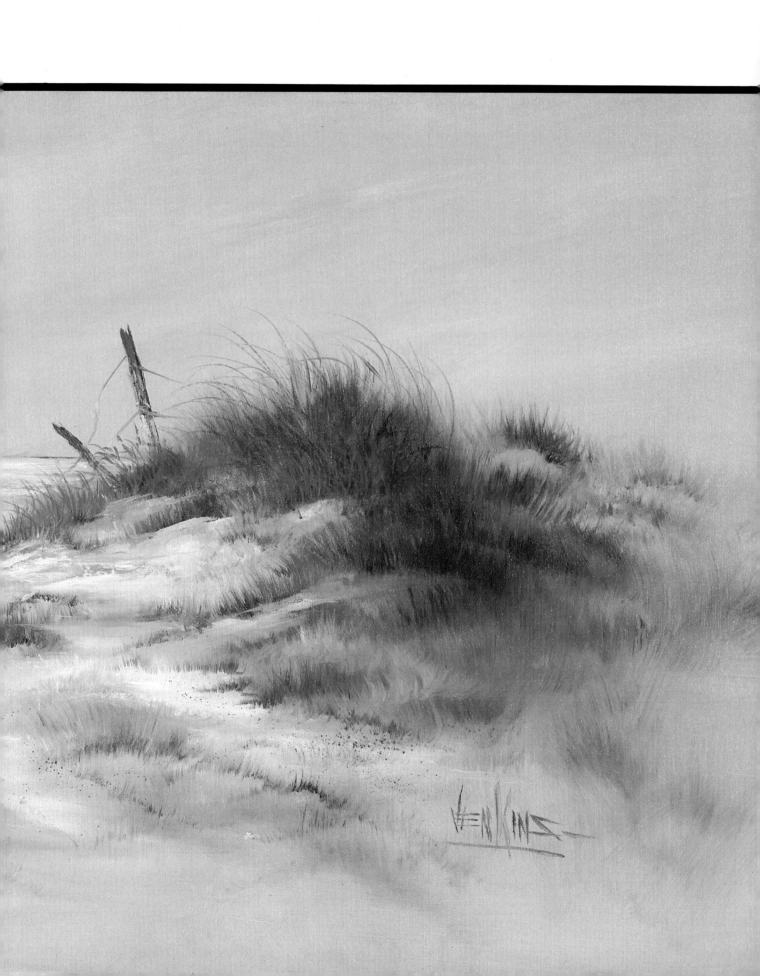

Stage 1
Sketch the dunes lightly with very little detail for placement only. Apply the background with a mixture of Burnt Umber, Cerulean Blue, and Misty Grey using criss-cross strokes. Develop the shadow areas falling on the sand from the dunes with a mixture of Mauve and Misty Grey. Lightly develop the horizon with a mixture of Phthalo Yellow Green and Burnt Umber.

Stage 2
Bring the horizon tones down between the dunes and fade them into the water. You can also develop the cloud area further at this time if you wish.

Stage 3

Creating the dune grasses will help you to master the use of the Jenkins Fan brush. Use a mixture of Burnt Umber and Phthalo Yellow Green on a "wet" brush and begin in the center of the large dune, working your way to the front and sides of the canvas. Create waves with Permalba White using either the Jenkins Chisel Flat or a painting knife.

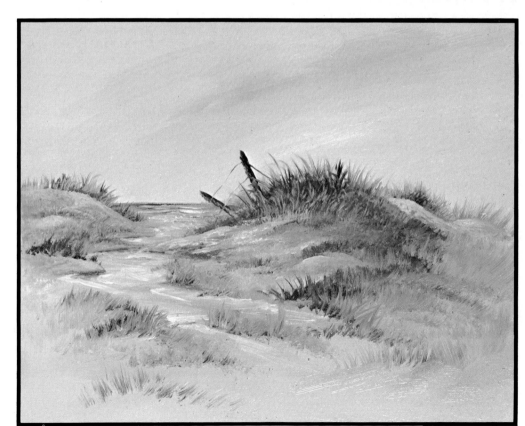

Stage 4

Accent the grass on the dunes, adding a little height to the grass at the top of the dunes. Develop little hills and dunes with the placement of the grass along with foreground. Add the fence posts or any other objects you might find along the beach.

SUMMER BYWAY

Colors

Burnt Umber Cerulean Blue
Misty Grey Permalba White
Mauve Cadmium Orange
Phthalo Yellow Green

Brushes

Jenkins 1" Badger Bright
Jenkins 2½" Super Soft Blender
Jenkins 1½" Super Soft Blender
Jenkins Fan
Jenkins Liner
Jenkins Chisel Flat

Canvas Preparation:

Using a 20 x 24 inch canvas, lightly sketch the dunes with a light lead pencil. Do not apply a lot of pressure so no indentation is made into the canvas surface.

Color Placement: *Background-Ocean and Sky*

Using a Jenkins Badger Bright, apply a mixture of Burnt Umber, Cerulean Blue, and Misty Grey to the canvas with crisscross strokes. Avoid color placement in the dune areas.

Color Placement: *Clouds*

Blend a small amount of Cadmium Orange with Permalba White for the cloud areas. This application will add warm color against the cool color of the sky. Use diagonal strokes with a 1½" Jenkins Super Soft Blender to develop a soft, cloud effect. This painting is designed to be a vignette where everything will fade into the background.

Color Placement: *Shadows*

Using the 1½" Jenkins Super Soft Blender, add a mixture of Mauve and Misty Grey below and around the right side of the center dune. This will develop a shadow falling on the sand from the dune. This color area should have a soft tone. Add a touch of Cadmium Orange to Permalba White, and using a diagonal stroke, add this to the lower, central area of the large dune. Repeat this on the smaller dunes, blending into the shadow area created with the Mauve and Misty Grey mixture.

Color Placement: *Horizon*

With the Jenkins Chisel Flat use a mixture of Phthalo Yellow Green and Burnt Umber to create, with horizontal strokes, a hint of a horizon between the dunes. Bring the strokes down toward the dunes, fading into the water.

Color Placement: *Grass*

Create a mixture of Burnt Umber and Phthalo Yellow Green for the grass. Starting in the center of the large dune and using a "wet" Jenkins Fan (a brush which has been dipped into Jenkins Happy Medium), hit the canvas with an upstroke, flipping the tip of the brush. The Jenkins Happy Medium should be applied only to the very tip of the brush.

As you approach the bottom of the dune, allow more sand to show through the grass. Pick up some of the color mixture used in the background and add a little more Burnt Umber as you work toward the bottom of the painting. When the paint begins to wear off the brush, use the same stroke to bring the sand color up into the grass.

Continue to work into the foreground, bringing the background color into the grass. As you work toward the edges of the painting, don't apply as much pressure so that the grass will fade away.

In the foreground water, lightly pull the grass up through the background color. Repeat the same procedure for creating grass on the other dunes, keeping a lighter tone compared to the main dune.

Color Placement: *Waves*

With the Jenkins Chisel Flat and Permalba White, create waves on and below the horizon with a zigzag stroke. Use the painting knife to pick up the Permalba White and push it down into the foreground and dune area by dragging the edge of the knife through the paint.

Color Placement: *Accenting*

Add Phthalo Yellow Green to Burnt Umber, and with the Jenkins Fan brush add sharp edges to some of the grass on the dunes, filling

in the heavily grassed areas and making the grass at the top of the dune a little higher. To the base of the dense grass area add a mixture of Cadmium Orange and Phthalo Yellow Green. Add a little straight Mauve to the base of the grass in the shadow area. You are developing patterns of grass growing between little sand hills which might not be visible otherwise.

Add a mixture of Mauve and Phthalo Yellow Green and accent the foreground of the small dune on the left. Take the Jenkins Liner and add a wet mixture of Burnt Umber, Phthalo Yellow Green and Jenkins Happy Medium to create stalks at the very top of the large dune. Soften these accents with the Jenkins Fan brush. Accent the areas around the base of the dunes with this same mixture using the Jenkins Fan brush.

Color Placement: *Fence Post*

On the top of the dune, add a post with a ragged top using Burnt Umber with the Jenkins Chisel Flat. You might add another post slightly falling over. Bury the bottom of the posts with grass using a mixture of Phthalo Yellow Green and Mauve. To accent the posts, add barbed wire or rope.

Finishing:

Sign your name using the Jenkins Liner and thinned paint. Let your paint dry thoroughly. After it is dry, apply several coats of Jenkins Sta-Brite Spray Varnish to bring out the color intensity.

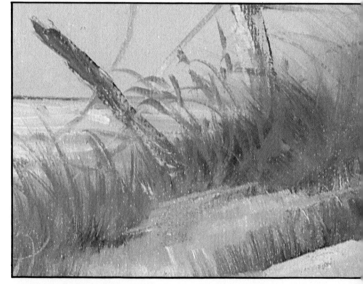

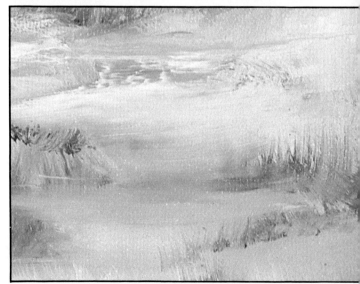

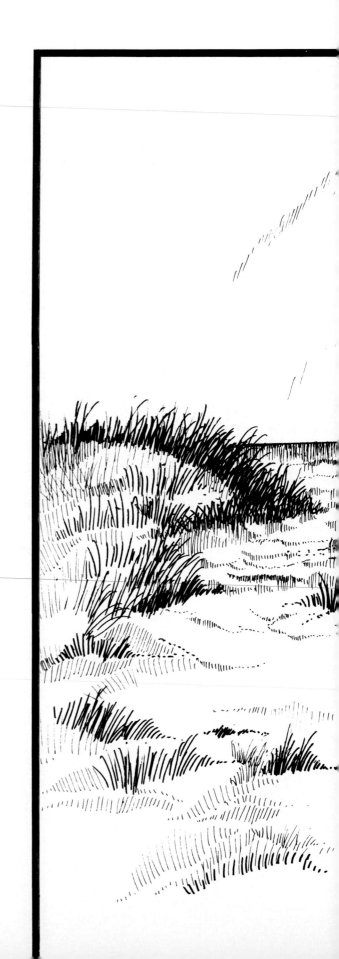

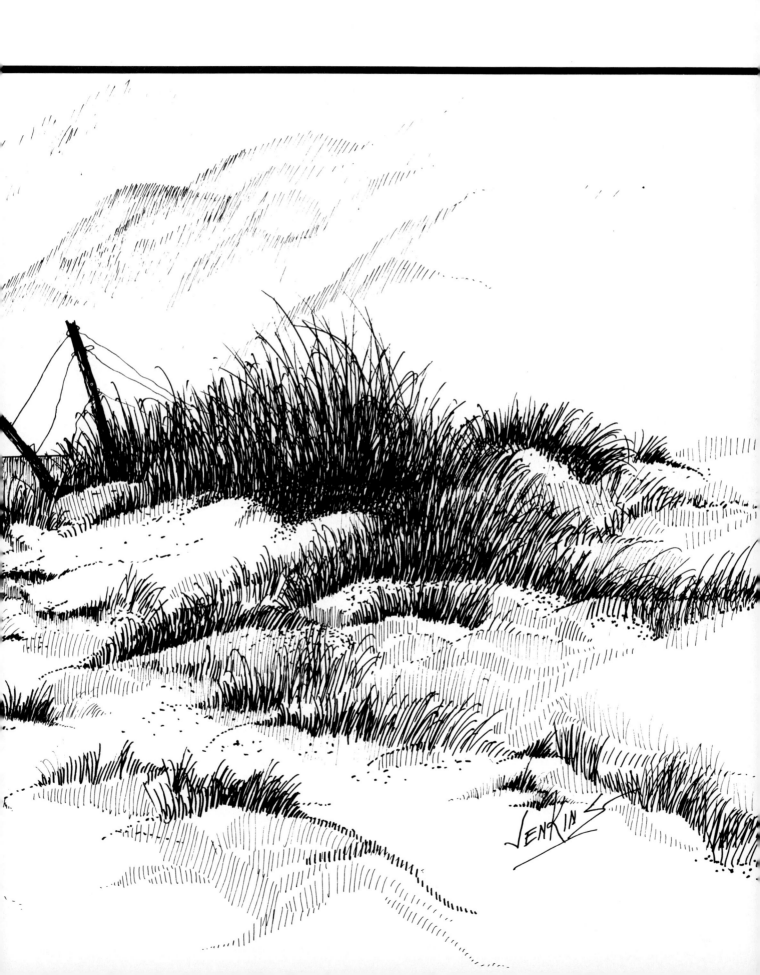

Nature's way of protecting eggs in a nest from potential predators is to camouflage them. It would be difficult to notice this nest if you were walking through the grasslands — the materials used in the building of the nest are merely an extension of the background.

All the earth tones appear to blend together, even with the significant highlighting and detail of the grass and nest. When painting the nest remember that things other than grass go into the making — leaves, twigs, feathers, and anything man or creature may have left along the countryside. I know you will truly enjoy this small piece of nature's wonders.

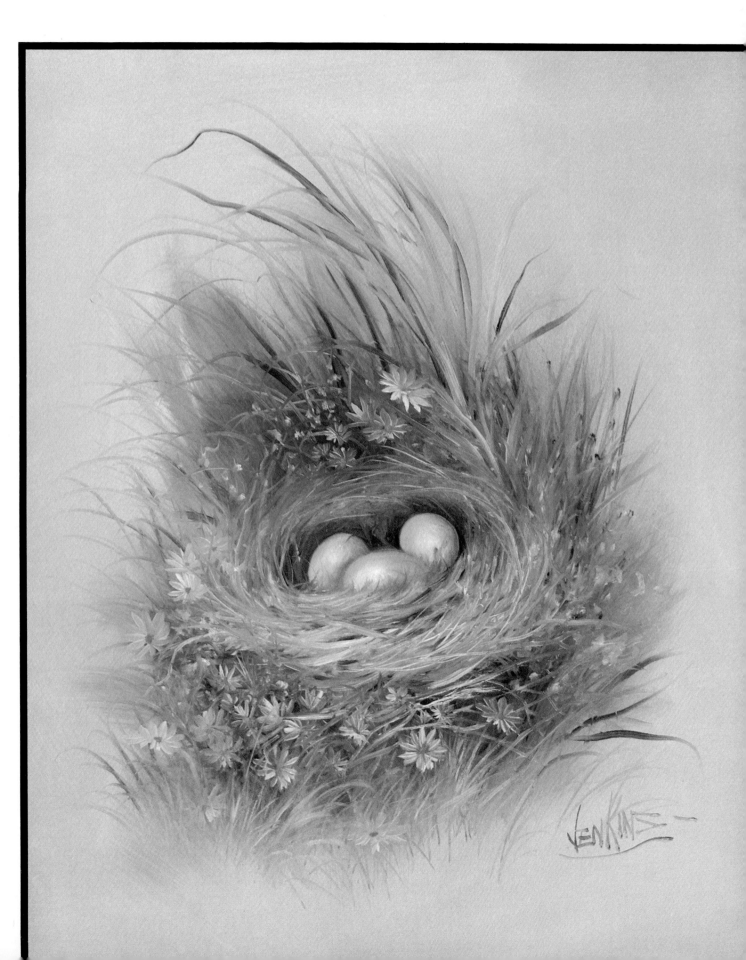

Colors

Misty Grey	Cadmium Orange
Burnt Sienna	Burnt Umber
Cerulean Blue	Misty Green
Permalba White	Cadmium Yellow Light

Brushes

Jenkins 2½" Super Soft Blender
Jenkins Chisel Flat
Jenkins Sable Round

Canvas Preparation:

Sketch a bird's nest on a 20 x 24 inch canvas lightly, taking care not to apply a lot of pressure so no indentation is made into the canvas surface.

Color Placement: *Background*

Using Misty Grey as a base tone, add a touch of Burnt Sienna and a touch of Cerulean Blue to paint the background around the nest with a Jenkins Super Soft Blender. Add a little more Burnt Sienna to the darker area in the upper left. Remember to keep the edges soft.

Work a little Misty Green into the Burnt Sienna up to the nest, leaving the edges ragged near the nest. This will act as a base tone for the leaves and grass. When applying this color curve the strokes to the left, getting a feeling of grass with each stroke.

Add darks under the nest to help add weight to the nest. Accent the background with more darks using a mixture of Misty Green and Burnt Sienna. Using the edge of the Jenkins Chisel Flat begin painting grass around the nest.

Color Placement: *Base Tone for the Nest*

With a mixture of Misty Green and Burnt Sienna, lay a dark tone in the center of the nest to bring the eggs out. Also place the darks around the nest. Pick up some Jenkins Happy Medium and work the darks into a wash, trying to get rid of the white of the canvas.

Color Placement: *Eggs*

With a mixture of Burnt Sienna and Cerulean Blue, place a little wash on the dark side of the left egg and the top side of the right egg. Using Permalba White, a little Cadmium Yellow Light and a dry brush, add highlights to the egg.

To highlight the center of the egg, use a mixture of Cadmium Orange and Permalba White. Apply the paint, wipe the brush clean, and then work the color into the egg.

Color Placement: *Background Darks*

Take the mixture of Burnt Sienna and Misty Green and stroke haphazardly around the nest, remembering to keep the strokes loose. Having a wet background will help you to do this.

Color Placement: *Nest*

Take the Jenkins Chisel Flat and Permalba White and highlight to indicate the twigs and other good things that went into the making of the nest. Keep your strokes thin and don't make the nest too tight. Try to indicate a few leaves and feathers, letting the strokes go in different directions. Let the paint set up a little before highlighting.

To highlight the nest, use Permalba White, very dry, with thicker strokes, sketching and stroking as you go along.

Color Placement: *Grass*

This nest is actually sitting in the grass. Using the Jenkins Chisel Flat, get a feeling for the grass by pushing down at the start of the stroke and then pulling up at the end of the stroke. Use a mixture of Misty Green and Burnt Sienna on a brush wet with Jenkins Happy Medium and create long strokes with an upstroke, curving the end of the stroke. You can use a downstroke for filler strokes. Keep the grass area loose. Place some grass under the nest and again, don't pull all the grass in one direction.

Color Placement: *Highlighting the Nest and Grass*

Using the Misty Grey and Burnt Sienna mixture, highlight the grass in the nest using varying thicknesses of lines. Create some blades shooting up and away from the main body of the nest. Notice that the back of the nest is darker than the front, making it recede

somewhat. Add a few longer blades at the top for height.

To highlight the grass use a mixture of Cadmium Yellow Orange and Permalba White and lighter strokes, trying to add a fullness to the grass. You can add detail with this color and bring out some of the front grasses.

Color Placement: *Daisies*

Using a Jenkins Sable Round create daisies with the push down-pull up stroke to taper the ends of the petals. Vary the shapes and pick up some of the background color. You can use just about any choice of colors — Permalba White, White and Cadmium Yellow Light, Turquoise, Pink or Orange. Daisies are found in abundance in the mountains so I don't think that you need any other flowers. Fill the area with daisies, varying their direction.

Finishing:

Sign your name using the Jenkins Liner and thinned paint. Let your paint dry thoroughly. After it is dry, apply several coats of Jenkins Sta-Brite Spray Varnish to bring out the color intensity.

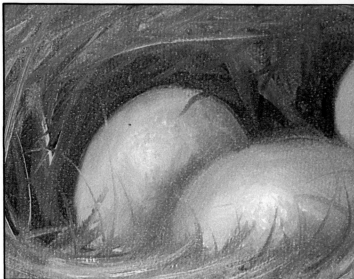

The following graph has been provided to enable you to enlarge the design. Increase the line graph double or more in size and sketch the design using this drawing as a guide. Do not feel you must copy it exactly — for you are the artist — create your own painting in the process.

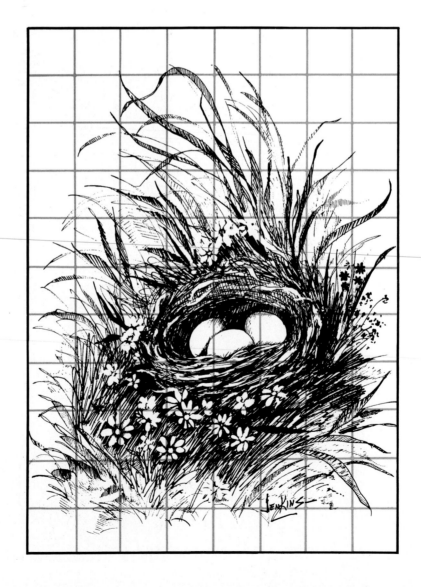

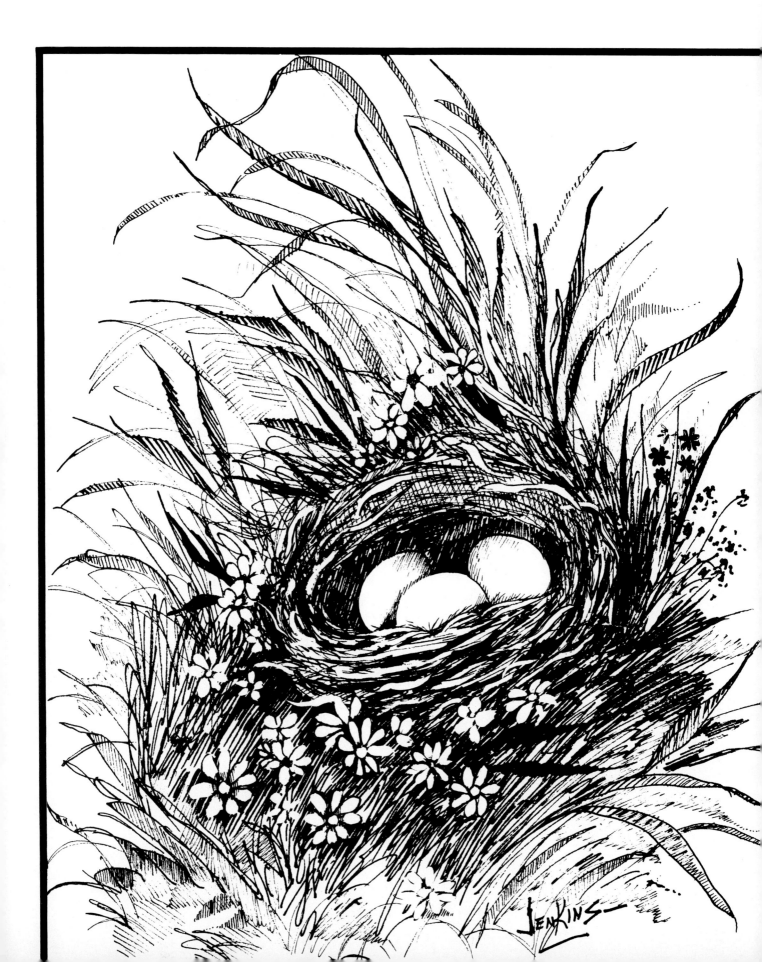

WINTER'S WALK

Imagine walking through the woods and stumbling across this scene! The contrasts between the white snow, the weathered barn, and the wildflowers popping through nature's winter blanket are perfectly balanced.

As with the sand dunes, the proper use of the Jenkins Fan brush is important to the creation of this scene. The Permalba White accents truly show the superiority of this product!

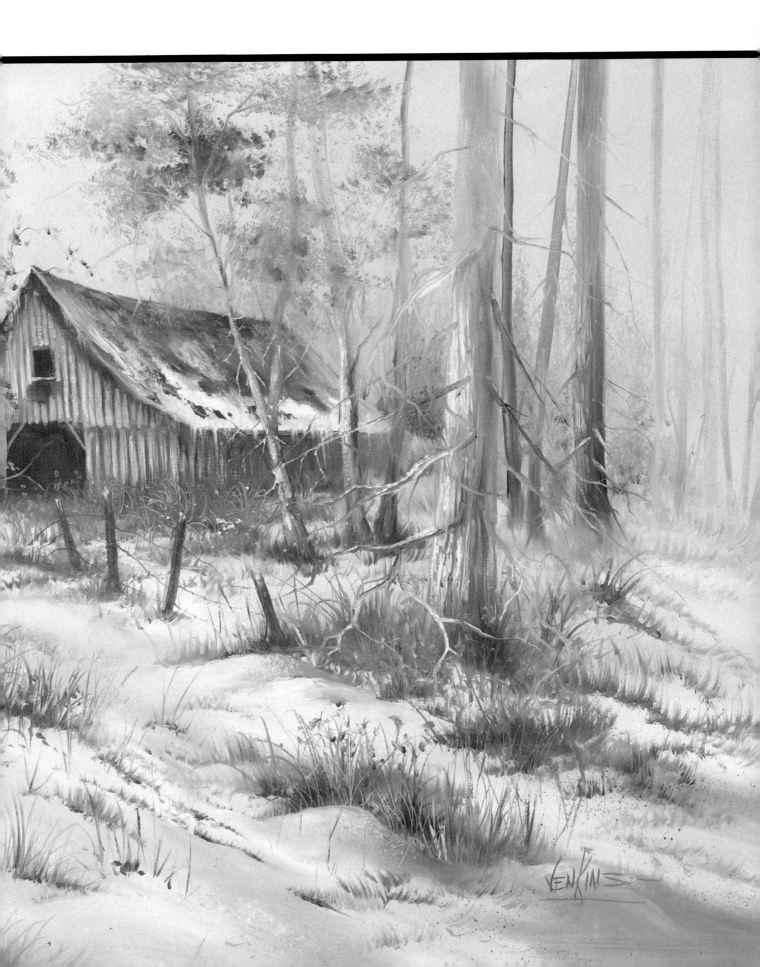

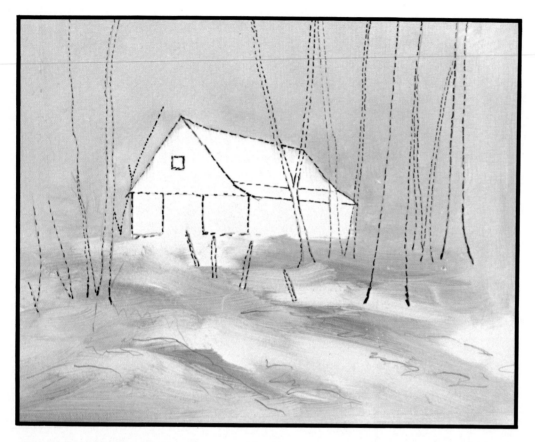

Stage 1

Lightly sketch a barn off center to the left. Add outlines of the trees but do not preoccupy yourself with detail: the sketch is used only as a guide.

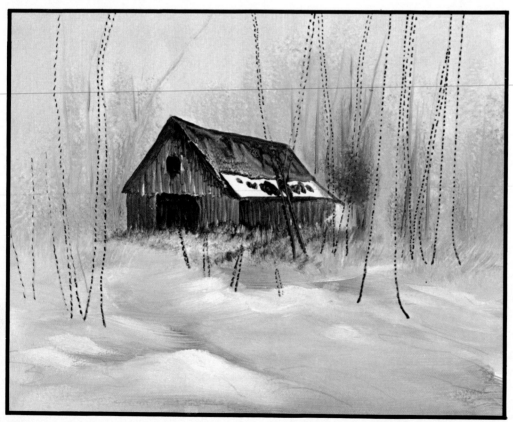

Stage 2

Place the background colors as indicated in the text. Create the trees to the right of the barn with a mixture of Cadmium Orange and Misty Grey.

Paint the barn with short vertical strokes to create a texture on the boards. The dark tones act as a foundation for the building. You can begin adding the grass around the barn with the Jenkins Fan brush.

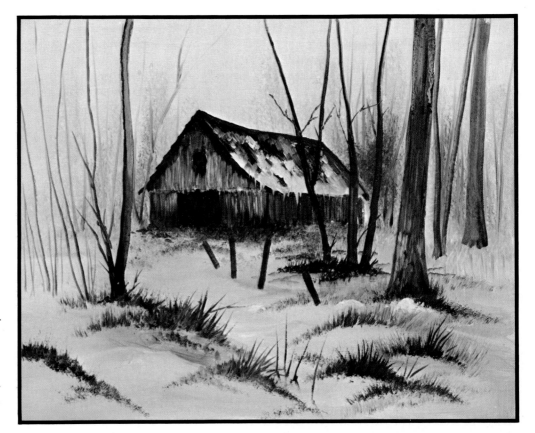

Stage 3

As you work the grass toward the foreground, pick up some of the base color so that the grass will fade as you approach the edges of the canvas. Fill in some of the trees as indicated. Accent the barn to develop a feeling for the boards. Indicate the snow on the roof.

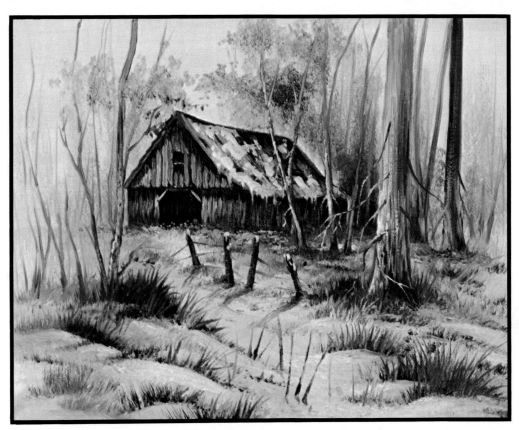

Stage 4

When working on the trees in the foreground, remember to use short choppy strokes to indicate the texture of the bark. You can use the Jenkins Tree brush to create the foliage in the background. Use a dry brush with Burnt Umber to indicate knots and bulges on the trees. Continue to highlight and accent until you are comfortable with the finished painting.

WINTER'S WALK

Colors

Burnt Umber	Permalba White
Burnt Sienna	Mauve
Cerulean Blue	Cadmium Orange
Misty Grey	Phthalo Yellow Green

Brushes

Jenkins 1½" Super Soft Blender
Jenkins 1" Badger Bright
Jenkins Fan
Jenkins Liner
Jenkins Chisel Flat
Jenkins Tree brush

Canvas Preparation:

Using a 24 x 30 inch canvas, sketch a barn a little to the left of center with the Jenkins Chisel Flat. Some artists who have had difficulty sketching will go out and take pictures of barns and have them developed into slides. They then project the slide onto the canvas and trace the barn. Another option would be to sketch from the inked design given.

Color Placement: *Background*

Add a little Burnt Umber and Cerulean Blue to Misty Grey and paint the background for the sky with a 1½" Jenkins Super Soft Blender. Add a little Mauve to the above mixture for the background. Work in a little Misty Grey with Cadmium Orange above the barn to add warmth against the cool color of the sky.

Color Placement: *Background Trees*

With a mixture of Burnt Umber and Mauve, load a Jenkins Tree brush and hit the brush on the area to the right of the barn, pushing the brush lightly into the canvas. These strokes will develop into leaves of trees. Add these trees to the left side of the barn, vignetting to the edge of the canvas with less pressure on the brush as you apply the strokes.

Add a little Phthalo Yellow Green to Burnt Umber and add some darker trees to the right of the barn — not too many, just enough to create a misty effect. If these trees overlap into the barn area, you needn't be concerned; the barn area will be painted over later.

Using the Jenkins Liner and a mixture of Burnt Umber and Mauve, with the brush dipped in Jenkins Happy Medium, add tall, thin trees with a little bend of varying heights to both sides of the barn. If you have trouble keeping the lines thin, wait until the background is drier. Don't push too hard while painting these trees as you don't want the trunks too thick.

With a mixture of Burnt Umber and Phthalo Yellow Green, and using the 1½" Jenkins Super Soft Blender, add push strokes to the base of the trees on the right side of the barn for accent.

Color Placement: *Foreground Snow*

With a clean Jenkins Super Soft Blender and a touch of Cadmium Orange to Permalba White, fill in the blank spaces in the foreground, creating a soft tone with no hard edges. Keep enough Jenkins Happy Medium on the brush so that the brush will slide easily. Fade the corners away, keeping the misty mood.

Color Placement: *Barn*

Note: Permalba Burnt Sienna is redder than other brands; it doesn't get muddy when it hits and mixes with white, lending itself as a perfect choice for landscapes.

Mix Burnt Sienna with Cadmium Orange, and using the Jenkins Chisel Flat paint the dark areas under the eaves and gently strengthen the outline of the roof.

With vertical strokes paint the door solid. This dark color acts as a skeleton to hold the barn together.

Wash the barn with vertical strokes of a mixture of Burnt Sienna, Burnt Umber and Jenkins Happy Medium. Add more Burnt Umber for the darker side of the barn. Paint the wash on the roof with care not to extend beyond the outline.

Darken the window with added Burnt Umber. Add a few dark strokes toward the bottom of the roof where the snow will later be placed. Add Burnt Umber with upward strokes to the bottom of the front of the barn to indicate the

staining which occurs as a result of rain splashing against the wood.

Color Placement: *Foreground Grass*

Using the Jenkins Fan brush and a mixture of Burnt Umber and Burnt Sienna, create the grass in the foreground. Start with the dark area near the barn and move outward and downward. As you pick up the base color the grass will begin to fade away. Angle the strokes for the grass to create hills. Remember to leave some of the base color showing through the grass.

Color Placement: *Accent - Foreground*

Accent the grass in the foreground with a hint of Cerulean Blue using the Jenkins Fan brush. With the Jenkins Liner, very wet with Jenkins Happy Medium, Burnt Sienna, and Burnt Umber, pick up and accent the tall pieces of grass. Add Cadmium Orange to add more accent to some of the tall grasses.

Color Placement: *Accent - Barn*

Add Misty Grey to the barn with the Jenkins Chisel Flat using vertical strokes. This will add a feeling of boards without clear definition; remember you are indicating boards, not providing intricate detail. Use Cerulean Blue and Permalba White to indicate boards on the shadowed side of the barn. When you are finished, clean up the dark edges around the eaves, window and door. Also indicate the stain under the barn window. Bring the grass at the base of the barn front back up.

Color Placement: *Barn Roof*

Add Misty Grey rather dry and haphazardly with the Jenkins Chisel Flat to the lower area of the roof to indicate snow. With a mixture of Burnt Umber and Burnt Sienna paint the tiles on the roof without a lot of detail. Add Burnt Sienna to the top of the roof to indicate staining. With the edge of the brush, using Permalba White, add white to the outside edges of the roof.

Color Placement: *Trees in Foreground*

Using a mixture of Burnt Sienna and Burnt Umber and the Jenkins Badger Bright, paint the trees to the top of the canvas, fading as they reach the edge. Paint them varied in size and direction. Make the strokes continuous so that you cannot see stops in the trees. Add the branches to the trees.

Color Placement: *Bark*

Add Burnt Umber to the base of the trees.

Add texture with short strokes using your Jenkins Badger Bright. With a mixture of Burnt Sienna and Burnt Umber, add grass around the base of the trees.

Color Placement: *Accenting*

To reflect the light on the right side of the trees, add Cerulean Blue to Permalba White and apply with the edge of the Jenkins Chisel Flat. Highlight the left side of the trees with a combination of Cadmium Orange and Permalba White. Use Burnt Umber to add darkness. If the Burnt Umber does not work now, wait until the background paint dries a little. Using a mixture of Burnt Umber and Burnt Sienna, wet the Jenkins Liner with Jenkins Happy Medium and lightly add limbs and branches to the trees.

Color Placement: *Foliage*

With the Jenkins Tree brush and a mixture of Burnt Umber and Phthalo Yellow Green, push the brush into the canvas to create the foliage in the foreground area.

Color Placement: *Additional Accenting*

Use the Jenkins Chisel Flat and Burnt Umber to indicate knots and bulges on the trees. A dry brush works well for this effect. Accent the grass in the foreground with the Jenkins Fan brush and a touch of Cadmium Orange. Accent the trees in the foreground with dry Permalba White to pick up light edges, using a Jenkins Liner. Use a little Cadmium Orange in Permalba White with the Jenkins Liner to detail the grass at the base of the barn front.

Finishing:

Sign your name using the Jenkins Liner and thinned paint. Let your paint dry thoroughly. After it is dry, apply several coats of Jenkins Sta-Brite Spray Varnish to bring out the color intensity.

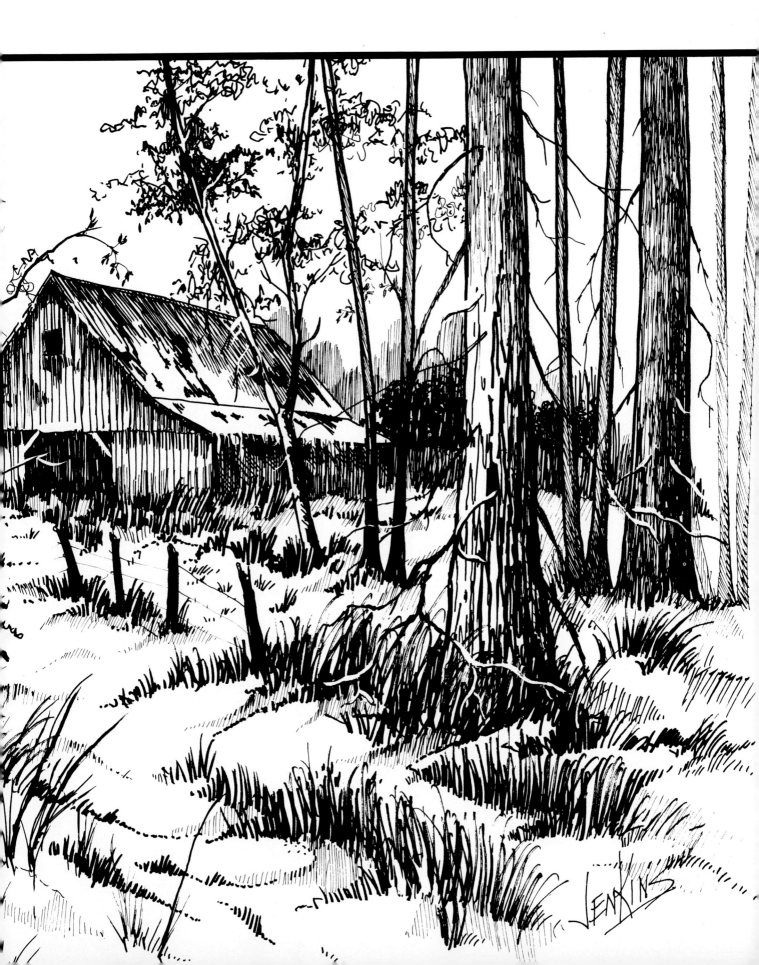

HIDDEN STREAM

Urban life has a tendency to deprive us of enjoying the simple, rustic beauties of the country. If you care to paint your own scene or add to this one, find your way out to the country — you will discover many subjects for your painting.

The trees are truly the focal point of this landscape, yet the stream plays an important part in pulling the entire painting together. Light creeps into the background through the path and stream created by the trees, and the borders of trees allow the wild flowers to grow.

This is a relatively easy painting to create. However, accurate color placement for the background is important for the rest of the painting to flow steadily.

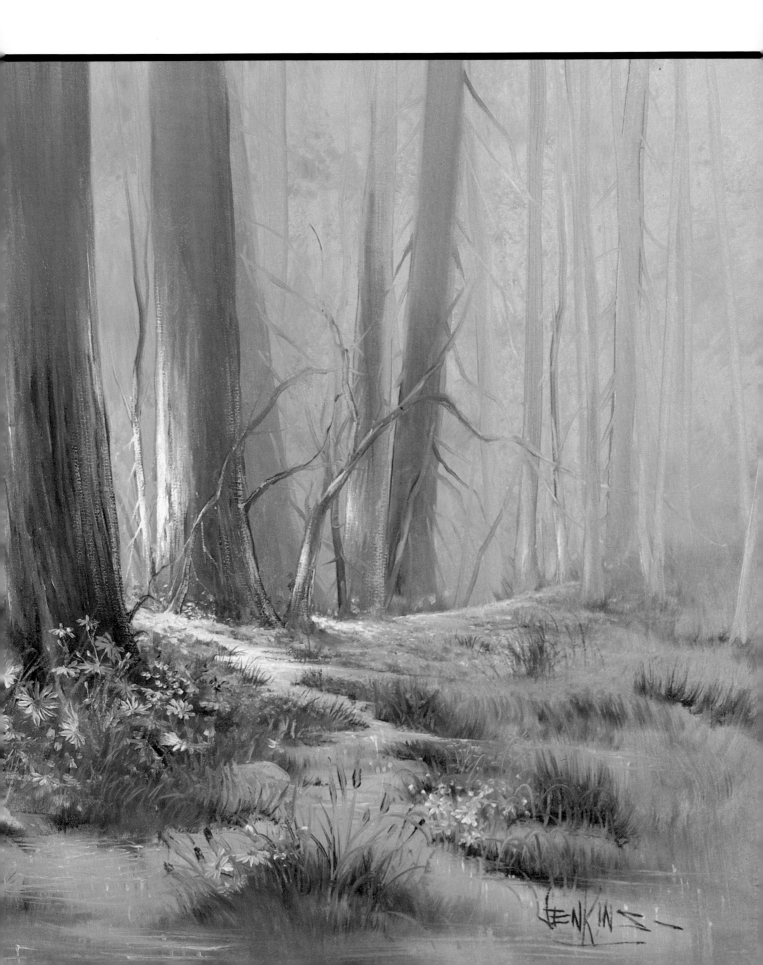

Jenkins

HIDDEN STREAM

Colors

Misty Grey	Turquoise
Misty Green	Raw Sienna
Cerulean Blue	Yellow Ochre
Burnt Umber	Floral Pink
Burnt Sienna	Permalba White
Cadmium Orange	Cadmium Yellow Light

Brushes

Jenkins Tree brush
Jenkins 2½" Super Soft Blender
Jenkins 1" Badger Bright
Jenkins ⅜" Flat
Jenkins Fan
Jenkins Liner
Jenkins Chisel Flat

Canvas Preparation:

On a 20 x 24 inch canvas sketch the landscape. Use a light lead pencil and be careful not to apply a lot of pressure so no indentation is made into the canvas surface.

Color Placement: *Background*

With a 2½" Jenkins Super Soft Blender, paint the sky area with a mixture of Misty Grey, Cerulean Blue and Burnt Umber. To this mixture add a little more Burnt Umber as you work toward the bottom of the canvas.

The water is a mixture of Cerulean Blue and Permalba White and is applied with the Jenkins Badger Bright in downward strokes. Develop an interesting path for the water.

Color Placement: *Background Trees*

Add more Burnt Umber to the basic mixture of Misty Grey with Cerulean Blue and Burnt Umber used in the background, and with the Jenkins Chisel Flat develop the trees. Use the flat of the brush for the wide trees and the side for the thinner ones. Fill in the area with trees as indicated.

With the Jenkins Tree brush, hit the trees with the end of the brush, using the basic mixture plus a little more Burnt Umber to develop a feeling of leaves. Do not stroke the area, just hit it with the brush. Blend this area with the 2½" Jenkins Super Soft Blender to soften up the edges and create texture so the trees will recede into the background.

After you have finished the leaves, put some of the tree shapes back in with the basic mixture. Add in the darker tree shapes with a mixture of Burnt Umber with Cerulean Blue. Fade the trees at the tops and flare the bottom of the trunks. To add depth work from the lighter colors of the background to the darker colors in the foreground. Angle some of the trees a little, but not enough to make them look as though they are going to fall over.

Use a mixture of Burnt Umber and Cadmium Orange to add some warmer colors to the wide tree just to the right of the large tree. Darken with Burnt Umber, using a combination of short and long strokes to develop texture. Repeat this procedure with the other midground, darker trees. A mixture of Cadmium Yellow Light and Cadmium Orange, added with very short strokes, will add even more texture to the bark of these trees on the left side.

Highlight the trees with a combination of Permalba White and Turquoise on the right side to indicate reflective light; we want a cool light on one side and warm light on the other. Further highlight with Permalba White which can be placed on the left side of the trunk.

Color Placement: *Large Tree*

With the Jenkins Badger Bright and a mixture of Burnt Umber and Burnt Sienna, block in the right side of the large tree. Use Burnt Umber and Raw Sienna to work toward the left of the tree trunk, adding to this mixture Yellow Ochre and Misty Grey. Scrub the colors into the canvas to enable them to blend properly. Pick out some more darks with short, choppy strokes; since this tree is close, more detail will show. Use short vertical strokes to darken the bottom of the tree and to help nail the tree down. Create some roots extending into the surrounding ground. These elements will create an anchor for the tree. Let the tree dry.

Color Placement: *Grass*

With the Jenkins Fan brush and a combination of Burnt Sienna and Misty Green, paint grass around the bases of the trees to hold them down. Remember to flip the brush on an upstroke. When you want a lighter shade push lightly; when you want a darker shade push harder. The grass should be darker in the front and lighter in the back. Continue filling in the grass area, but leave some of the background showing in the foreground, sides, and stream area. Use shorter grass strokes in the background to develop perspective.

Color Placement: *Stream*

Using the Jenkins Badger Bright loaded with Cerulean Blue and Permalba White, bring the water down with short horizontal strokes, then switch to short vertical strokes to blend the color and set the stream into the scene. With Misty Grey and a touch of Burnt Sienna, put grass around the edges of the stream. Stroke grass on, using your Jenkins Fan brush. Highlight the water with Permalba White, using the Jenkins Badger Bright, stroking color on in short horizontal strokes.

Color Placement: *Branches*

Using the Jenkins Liner and a mixture of Burnt Umber, Burnt Sienna, and Misty Green, randomly place some branches on the trees. Vary their size and tones. To darken the branches, accent with Burnt Umber and Cerulean Blue on the lower portion of a branch.

Color Placement: *Highlighting*

With the Jenkins Fan brush and a mixture of Burnt Sienna and Raw Sienna, add some warm color to the grass at the base of the trees. Lighten the area between the trees in the background to indicate a warm light coming through. This can be done with a mixture of Yellow Ochre and Cadmium Orange followed by a mixture of Cadmium Yellow Light and Cadmium Orange.

With the Jenkins Liner detail the grass, using a mixture of Misty Green, Cadmium Orange and Cadmium Yellow Light. Add longer grass with Misty Green and Burnt Umber, and perhaps you can indicate some cattails or other wild flowers in a dark silhouette manner.

Accent the light passing through the trees in the background with Permalba White and Cadmium Yellow Light, creating little flower

beds. Add more flowers with Floral Pink and Permalba White. When placing the flowers try to form a pattern or grouping; random placement can make the picture look "spotty".

Accent the edges of the stream by placing additional grass strokes, using Burnt Umber with the Jenkins Fan brush. Pull some grass down into the water to indicate reflections by pulling the brush down and then across for a rippling effect.

Color Placement: *Rocks*

With the Jenkins Flat paint rocks of irregular shapes, using a mixture of Burnt Sienna and Burnt Umber. Accent the tops of the rocks with Permalba White and Floral Pink to pick up light tone. Place some grass around the rocks to set them down. Create a variety of sizes of rocks with a mixture of hard and soft edges. Some of the rocks will just blend into the background. If you have trouble drawing the rocks, you can get a pebble from your yard and use it as a guide.

Color Placement: *Wildflowers*

Using the Jenkins Liner and a mixture of Floral Pink and Permalba White, spot some flowers around the rocks. Add some more flowers with Cadmium Yellow Light, fading them into the background. With Misty Green and Cadmium Yellow Light, add some grass growing in and around the flowers and rocks. Stroke on flowingly and gracefully.

Color Placement: *Accenting and Highlighting*

Highlight the stream with additional Permalba White to add a little sparkle.

With the Jenkins Liner and Permalba White and a touch of Floral Pink, place some daisies around the base of the large tree. Bring the daisies into the foreground, adding some Misty Grey to this color mixture.

Use a mixture of Burnt Umber and Burnt Sienna to add a few small trees in the background area if needed. Indicate leaves with Misty Green and Burnt Sienna where necessary, using a dabbing motion with the Jenkins Tree brush. Add some Cadmium Orange, Misty Green, and Cadmium Yellow Light to accent the leaves.

To have some background flowers create a carpet of color in the back area, hit the area with the Jenkins Fan brush. Use combinations

of Floral Pink and Permalba White, and Cadmium Yellow Light and Permalba White to do this.

Soften the edges with a Jenkins Super Soft Blender so that the painting fades into the background on all four sides.

Finishing:

Sign your name using the Jenkins Liner and thinned paint. Let your paint dry thoroughly. After it is dry, apply several coats of Jenkins Sta-Brite Spray Varnish to bring out the color intensity.

Additional Artwork

We thought you would enjoy viewing some paintings by Gary, depicting his versatile talent of truly any subject matter. In the future, look for other publications featuring his unique style.

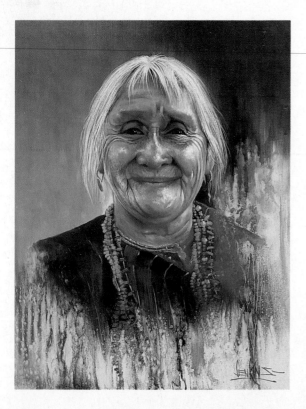